IMAGES
of America

FAYETTEVILLE

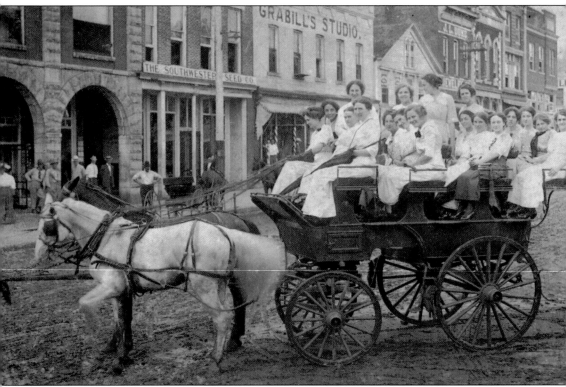

More than a dozen sorority sisters from the University of Arkansas take a trip around the Fayetteville square in 1913 in a horse-drawn omnibus. For more than 180 years, the center of Fayetteville's commercial and social interchange has been the square. (Photograph by Burch Grabill; courtesy Shiloh Museum of Ozark History/WCHS Collection, P-119A.)

ON THE COVER: The site of W.H. Jordan's Wagon and Carriage Works stood on the location of the Butterfield Overland Mail Company's stables. By the late 1880s when this photograph was taken, horse-drawn vehicles were still in great demand, and Jordan offered a variety of buggies, carriages, and hacks for rent, many of which advertised local businesses such as Bates Brothers Grocery. The two-story brick structure was taken down in the early 1900s to make way for construction of the Washington County Courthouse in 1905. (Courtesy Shiloh Museum/WCHS Collection, P-333.)

IMAGES
of America

FAYETTEVILLE

Charles Y. Alison and Ellen K. Compton on behalf
of the Washington County Historical Society

ARCADIA
PUBLISHING

Published by Arcadia Publishing
Charleston, South Carolina

Printed in the United States of America

Library of Congress Control Number: 2011921757

For all general information, please contact Arcadia Publishing:
Telephone 843-853-2070
Fax 843-853-0044
E-mail sales@arcadiapublishing.com
For customer service and orders:
Toll-Free 1-888-313-2665

Visit us on the Internet at www.arcadiapublishing.com

Dedicated to William Simeon Campbell and Walter J. Lemke

CONTENTS

ACKNOWLEDGMENTS

This pictorial history of Fayetteville would not have been possible without the wonderful help of people who found and processed the images here. Marie Demeroukas and Cheri Coley of the Shiloh Museum of Ozark History provided advice and help with the Washington County Historical Society's photograph collection as well as many hours of scanning and fact-checking. Similarly, Annie Dowling offered help and service with the many photograph collections held by the Department of Special Collections at the University of Arkansas Libraries. Tim Nutt and Patrick Williams, members of the Washington County Historical Society's publications committee, gave their time to put an extra set of eyes on the text compiled for this book, saving the authors many errors. And the authors have to thank their Arcadia editor, Amy Perryman, for being patient when possible and prodding the project when necessary. Due acknowledgment is also owed to the many photographers who have chronicled Fayetteville's history.

Most of the images in this work were collected by the Washington County Historical Society (WCHS) during its 60-year tenure as an organization dedicated to the preservation and promotion of history in Washington County, Arkansas. Most of the photographs came from two sources: the Shiloh Museum of Ozark History in Springdale, Arkansas, and the Department of Special Collections of the University of Arkansas Libraries at Fayetteville.

The photographs from the Shiloh Museum of Ozark History, credited as Shiloh Museum hereafter, are from the Washington County Historical Society Collection.

The photographs from the University of Arkansas Libraries, credited as UA Libraries hereafter, come from several collections, but primarily from the William Simeon Campbell Collection (WSC Collection) and the McIlroy Bank Collection (MB Collection). The names of smaller collections are listed with their credits.

INTRODUCTION

The photographs collected here depict Fayetteville, Arkansas, from the 1870s to the 1960s, the period in which Fayetteville grew from small village to big town. The size of the book and the large number of photographs available dictated a narrow window of time. Photographs of the University of Arkansas have, for the most part, not been included due to the size of this project and the focus on the town itself. The authors have attempted to present images not used before.

In 1828, the United States traded land in the present state of Oklahoma to the western Cherokees who were living across a swath of land in the northwest part of the Arkansas Territory, between the Arkansas River and the White River. When the western Cherokees moved farther west, a minor land rush occurred, and a half dozen families pitched camp on and near an eminence of land overlooking the valley of the West Fork of the White River. The small town formed by these families was soon named the county seat of the newly established Washington County.

Originally called Washington Court House, the name was soon changed because the US postmaster determined that another Arkansas town was already named Washington. Town commissioners voted in 1829 to name the town Fayetteville, in part because two of them had come to Arkansas from Fayetteville, Tennessee. In short order, merchants, farmers, lawyers, and bankers were building a small center of commerce and trade on the grand eminence.

The town was platted in 1836, with a courthouse at the center of the square surrounded by offices, shops, and stables on the perimeter. A branch of the Arkansas State Bank was established at Fayetteville. In the winter of 1838–1839, the eastern Cherokees were forced from their homes in North Carolina, Georgia, Tennessee, and Alabama and marched to the Indian territory just west of Arkansas. At least two major groups came through Fayetteville, one stopping on the south side of town to get supplies and make repairs to wagons, and a second that came through the Mount Comfort community. Slightly ahead of them came a missionary, Sophia Sawyer, who started the Fayetteville Female Seminary in 1839, and Sarah Bird Northrup Ridge. The school became well known throughout the southwest for its educational attainments. The city's first newspaper, the *Witness*, began publishing the next year. The publication lasted only a year. Not until the 1850s did newspapers find enough advertising to support their trade. Many of Fayetteville's churches were established during the 1840s, showing the slow but steady settling of the frontier ways. In the early 1850s, Robert Graham established Arkansas College, which soon enjoyed a reputation as strong as the Fayetteville Female Seminary, attracting young men from Arkansas, Louisiana, Texas, the Indian territory, and as far away as England. At the end of the decade, the Butterfield Overland Mail Company established operations through Fayetteville on its stage route from St. Louis to San Francisco. By 1860, two newspapers were competing for readers, and the Stebbings telegraph connected Fayetteville with St. Louis.

What was built in 30 years, though, took but three to dismantle. The Civil War brought ruin to the town. Confederate troops burned most of the square in late February 1862, along with many other buildings deemed to be of military value. Several major buildings that escaped the

initial conflagration, such as Arkansas College, the county courthouse, and the Female Seminary, caught fire later during the war. Fayetteville was a shell of its former self by 1865.

Town leaders rebuilt, establishing the first public school district in the state and the first public school for black students. The school, initially known as the Mission School, from which Mission Boulevard takes its name, was built on Olive Avenue near its intersection with Sutton Street. A year later, in 1871, Fayetteville successfully bid to be the location for the state's first land-grant university. As before the Civil War, the people of Fayetteville invested in education and reaped both financial and social rewards. Although the end of Reconstruction in Arkansas hurt the progress being made in Fayetteville, many efforts were carried forward.

Early in the next decade, the St. Louis and San Francisco Railway built a line into Fayetteville, headed for Paris, Texas. The line provided Fayetteville's first easy access to markets, both for importing goods and exporting produce and raw materials such as lumber. Fayetteville's agricultural, manufacturing, and processing industries grew during the late 1800s and early 1900s at a rapid pace along the railroad tracks, even as the tracks themselves were being built toward new locations: St. Paul, Arkansas, to the east and Muskogee, Oklahoma, to the west.

As with the rest of the country, the mass production of automobiles in the early 20th century and the mass distribution of motion pictures changed the city more than anything else. Competing musical bands were organized, playing behind the silent pictures. Stables gave way to filling stations. Highway 71 was paved to Van Buren in the 1920s. Whole blocks of commercial buildings were torn down for parking lots. None of it happened quickly, but by the 1960s, Fayetteville's main street, College Avenue, known for its tree-lined beauty through the 1950s, became a strip of eat-fast or drive-past shops that used up more and more space for parking and less and less space for actual customers.

From the 1850s onward, however, downtown Fayetteville was the place to see parades—everything from P.T. Barnum's Greatest Show on Earth to the Fayetteville High School homecoming, from Armistice Day to Veterans Day—if there was a celebration, there was, as often as not, a parade that found its way to the square. Likewise, the city had been home to opera houses and vaudeville stages since the late 19th century, many of which also doubled as movie houses.

During the 1940s and 1950s, Fayetteville stood at the vanguard of integration. Unlike towns in the rest of northwest Arkansas, Fayetteville's racial mix included African American residents. Unlike most towns in south and east Arkansas, the population of African Americans in Fayetteville was small, about two percent of the total population. The small size of the black community made integration a simpler decision for the white population in Fayetteville, but it did not make the act of integration any easier for the students who stepped forward to end racial segregation. In 1948, Silas Hunt was the first black student to enroll at the University of Arkansas since Reconstruction, making Arkansas the first traditionally white university in the south to integrate without threat of lawsuit. Six years later, after the US Supreme Court ruled that separate education was inherently unequal, the Fayetteville School Board voted to integrate its high school, becoming one of the first two schools in the south to integrate. Preston Lackey and Peggy Taylor led the first wave of black students to attend the high school.

Very little photographic record of Fayetteville exists for the first 40 years of the city's history, save occasional family portraits made by eastern photographers. There are, however, a smattering of antebellum buildings that have survived. Along with two well-known lithographs—Arkansas College and the Fayetteville Female Seminary—they provide some broad sense of how the early residents of Fayetteville lived.

This collection shows the shift from the rough-hewn board-and-batten buildings thrown together in the first days after the Civil War to the latest in small-town modernity, a drive-through bank—the change from the muddy streets and wooden boardwalks of the 19th century to the car-dominated culture of the 20th century.

One

THE PUBLIC SQUARE

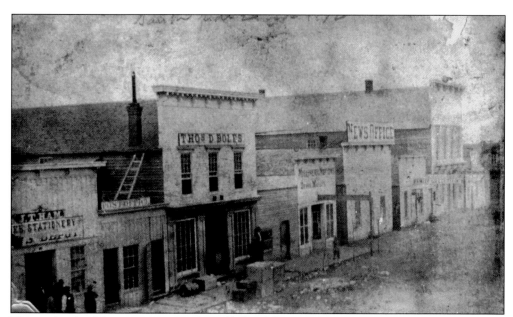

The south side of the square, in 1872, lagged behind the rest of the square when construction started anew after the Civil War, but it didn't lack variety. From left to right are J.T. Ham's bookshop, the post office, Thomas D. Boles's store, a millinery and dressmaker, the *Fayetteville News* office, John Blakely's cabinet and furniture shop, and a family grocery. Crenshaw's Hardware Company is on the far right. (Courtesy UA Libraries/WSC Collection, MC1427.)

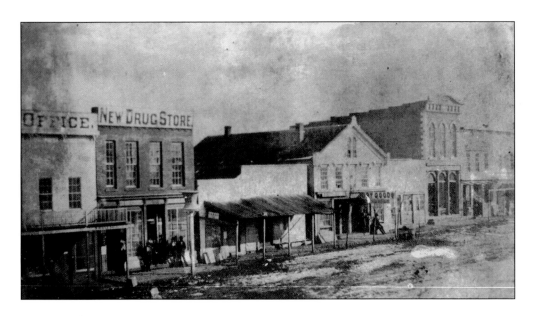

A very early view of the north side of the square (above) shows the town in 1872 as it rebuilt after the Civil War. Establishments on the block include a wholesale business at left, Peacock and Pendleton's new drugstore, a small cake shop, a dry goods store, and the tall two-story Stark Bank. By the end of the decade, more brick buildings had filled in the space (below). Gus Albright operated a hardware store at the center of the block, Stark Bank had become McIlroy Bank, and the Arkansas Industrial University had completed construction of its main building, visible to the northwest of town on the horizon. (Both courtesy Shiloh Museum/WCHS Collection: above, P-140; below, P-141.)

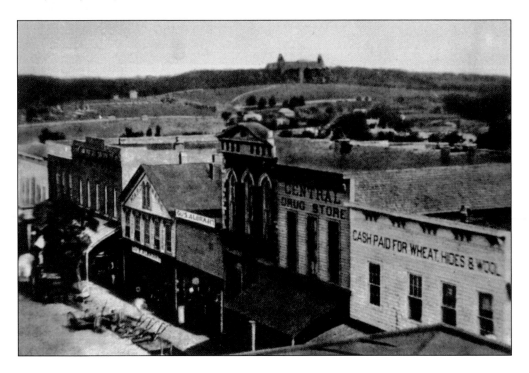

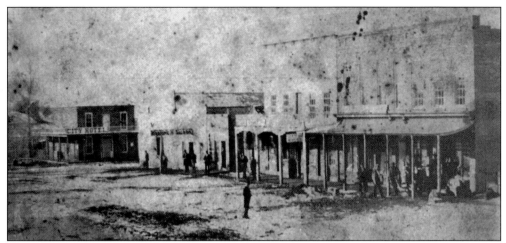

One of the earliest photographs of Fayetteville, taken around 1872, shows the west side of the square. The City Hotel, at the southwest corner, was built by H.L. Glass. To the right of City Hotel is the Morning Saloon, two small frame buildings, and then a general merchandise store that was opened by Henry Wayland not long after the Civil War. Wayland's store is where Campbell and Bell later operated. (Courtesy Shiloh Museum/WCHS Collection, P-499.)

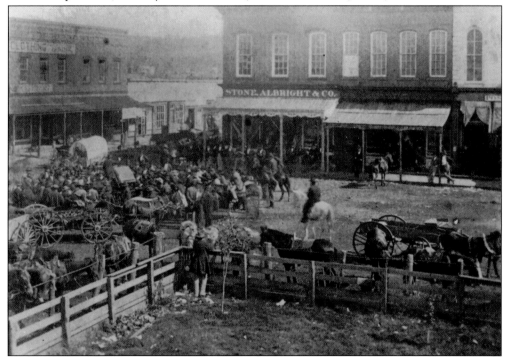

A public auction is being conducted at the northeast intersection of East Avenue and Center Street on the square around 1878 in this photograph, taken from the upper floor of the 1870 Washington County Courthouse. The businesses flanking the far side of the intersection are Reed and Ferguson on the left and Stone, Albright and Company on the right. Stephen K. Stone came to Fayetteville in 1840 and eventually built a brick store on the square at the north end of East Avenue. His building was one of the few that survived the Civil War. (Courtesy Shiloh Museum/WCHS Collection, P-122.)

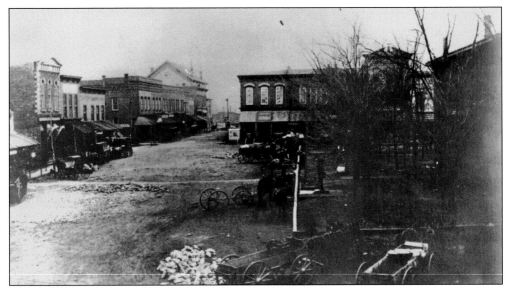

The northeast corner of the square in 1892 included McIlroy Bank at the far left and Stephen K. Stone's mercantile at the center of the photograph on the northern end of the block. The *Fayetteville Democrat* operated in offices at the building on the corner, and the tall Van Winkle Hotel can be seen down Center Street. The building in shadow at the right is the 1870 Washington County Courthouse, located at the center of the square. On its north side is a water pump and hitching rail for the many wagons and buggies that came to the square for business. (Courtesy Shiloh Museum/WCHS Collection, P-491.)

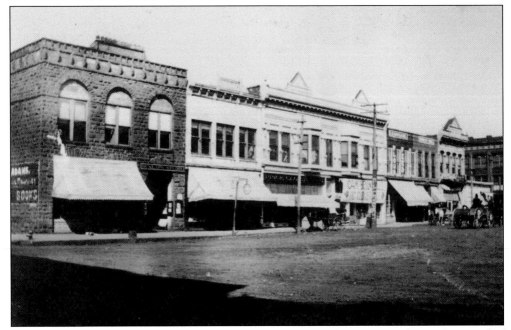

A.C. McAdams operated a drugstore and bookstore (left) on the square at the southern end of Block Avenue, while Dunlap's Studio operated upstairs, pictured sometime in the 1910s. In the middle of the block stood Price Clothing Company and Campbell and Bell Dry Goods Company. (Courtesy Shiloh Museum/WCHS Collection, P-121.)

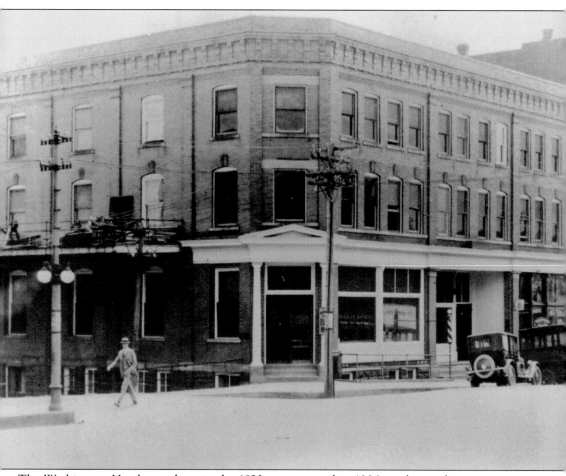

The Washington Hotel, seen here in the 1920s, was erected in 1906 on the southwest corner of the square, the site of the original First Christian Church and later the Tremont and City Hotels. In the front corner of the building, the Arkansas National Bank operated. In the 1950s, freshman female students were housed in the hotel when the university campus ran out of space. The building was razed about 1960, and the F.W. Woolworth Company rebuilt on the site. It is now office space. (Courtesy Shiloh Museum/WCHS Collection, P-127.)

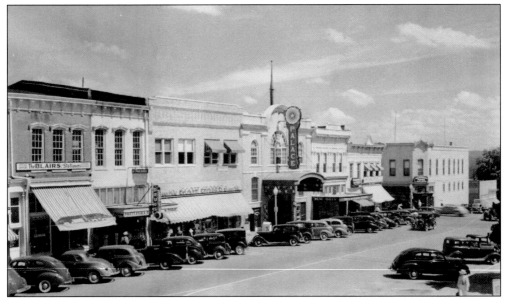

The neon lights of the Palace Theater, pictured about 1940, dominated the east side of the square. Showing this particular week was *Queen of the Mob*, based on J. Edgar Hoover's novel of the same name and starring Ralph Bellamy as an FBI agent. Also operating on the street were, from left to right, the Blairs Stationers, Fayetteville Drug Store, the Scott Store, the Palace, the Doty Food Market, Coleman's Shoes, and Chandler Real Estate at the north end of the block. At the corner is Guisinger's Pianos. (Courtesy Shiloh Museum/WCHS Collection, P-124.)

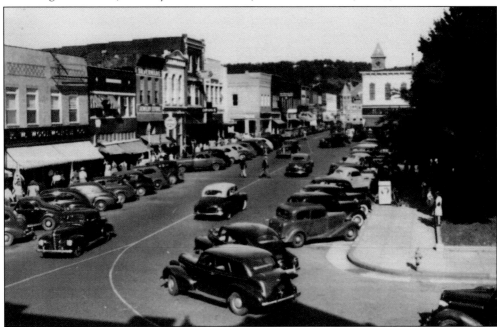

In the 1940s, Center Street still handled two-way traffic. The north side of the square was the commercial hub and included the F.W. Woolworth Company, Silverman's Jewelry Store, McIlroy Bank, the Red Cross Drug Store, and the Boston Store. (Courtesy UA Libraries/WSC Collection, MC1427.)

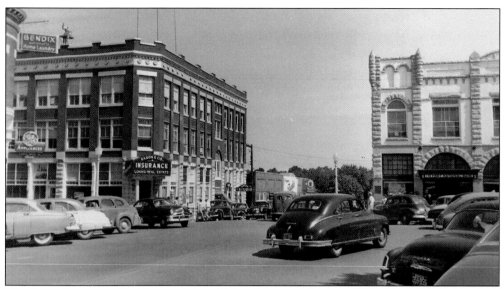

The Eason Insurance Building and the old First National Bank Building (above) flanked Block Street on the north side of the Fayetteville square in 1952, when this photograph was taken. The facades of both buildings were covered during the 1960s. The Eason Building's gold covering was removed in the 1990s to reveal the original underlying stone and brick. The First National Bank Building was covered in marble and metal that until late 2010 remained intact. A windstorm on the last day of the year knocked marble plates off the southwest corner. The interior of the Eason Insurance Building (below), with its marble counters, iron safe, and Frisco calendar, suggest an office more in keeping with a bank, which it had been, previously holding the first Bank of Fayetteville. (Both courtesy UA Libraries/WSC Collection, MC1427.)

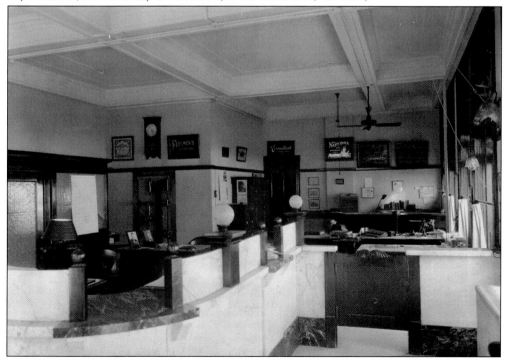

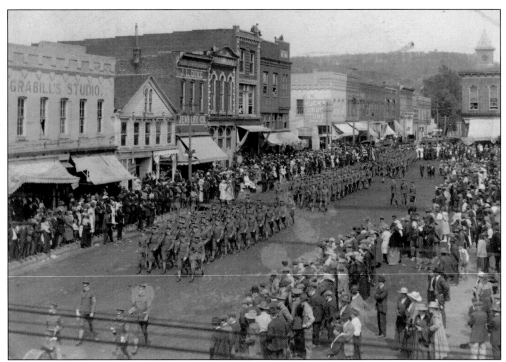

After World War I, the square filled with university cadets and crowds of spectators celebrating Armistice Day. (Courtesy UA Libraries/WSC Collection, MC1427.)

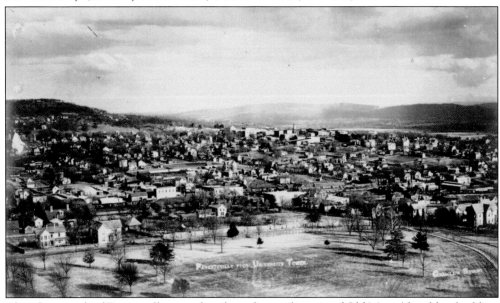

This photograph of Fayetteville was taken from the south tower of Old Main (the oldest building on the university campus) about 1903. It looks southeast across the front lawn of campus toward the Fayetteville square. The street crossing the foreground is Arkansas Avenue, with Dickson Street coming in from the right. The small white cupola rising above the downtown buildings is the top of the 1870 Washington County Courthouse when it stood at the center of the square. (Photograph by Burch Grabill; courtesy Shiloh Museum/WCHS Collection, P-489A.)

Two

A Sense of Place

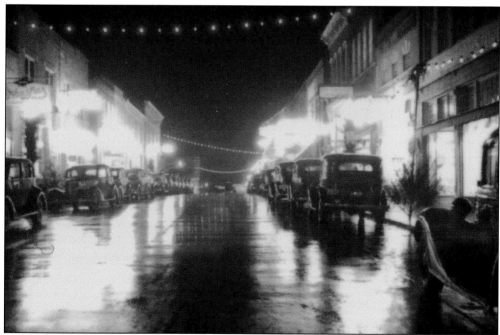

This c. 1935 view, facing west on East Center Street toward the square, has a particularly festive glow for the holidays because of the wet streets and the decoration of the street poles with holly and evergreen. On the far right is Linkway Stores. To its left is the Quaker Drug Store. On the opposite side of the street is the Cravens Building, barely visible amid the night's bright lights. Although the square has had holiday lights since the beginning of the 20th century, the city boosted the number of bulbs into the millions in the 1990s when it started the Lights of the Ozarks. (Courtesy UA Libraries/Bennett Collection, Sheet 98.)

When Archibald Yell began serving as a territorial circuit judge for western Arkansas in 1835, he built a house at Fayetteville that spared no expense. He named his estate Waxhaws. Yell was elected the first congressman from Arkansas after statehood and its second governor. He died in 1847 at the Battle of Buena Vista during the Mexican War. The building was razed in the 1960s, but the Washington County Historical Society saved Yell's one-room law office and moved it to the grounds of Headquarters House. Today, the Fayetteville Senior Center stands near the site of the home. (Courtesy Shiloh Museum/WCHS Collection, P-370.)

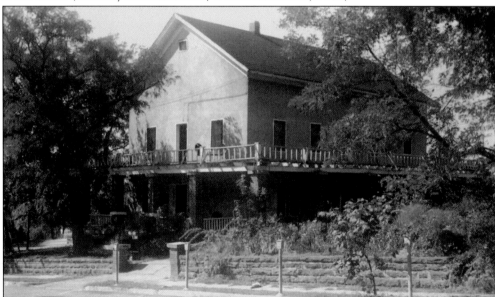

Fayetteville's Masonic Hall, seen here in the mid-20th century, was built in 1840 on the northwest corner of Rock Street and Block Avenue, on land deeded to the lodge by Archibald Yell, by then serving as the second governor of Arkansas. The Mountain Lodge was the first Masonic lodge organized in Arkansas. By the early 1920s, Dr. J.F. Stanford and Etta Stanford had acquired the building and used it for their home and the Stanford Veterinary Service. The Stanford family continued to own the building until the early 1960s, when it was razed to make way for the construction of a new municipal police office. (Courtesy Shiloh Museum/WCHS Collection, P-332.)

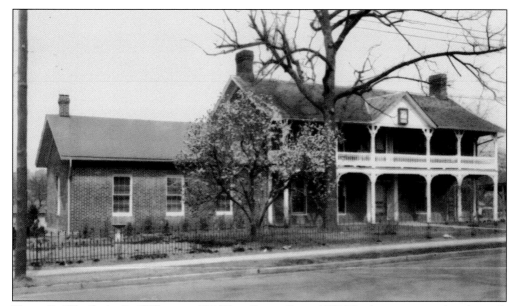

Henry Reiff built the Reiff House at 206 West Center St. in 1857. The home, pictured in the mid-20th century, was used as a commissary by Confederate troops stationed in Fayetteville during the early part of the Civil War and as a hospital for Union troops after the Battle of Prairie Grove. In 1941, A.D. and Margaret Callison purchased the building and opened a funeral home that eventually became Moore's Funeral Home and Chapel, which still operates on the site. (Courtesy Shiloh Museum/WCHS Collection, P-2656.)

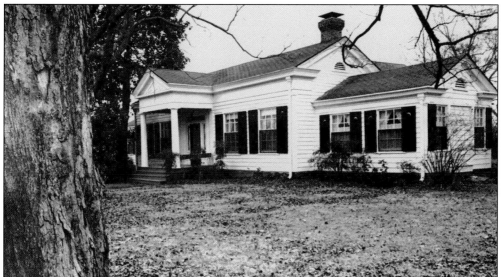

Built by Jonas March Tebbetts and Matilda Tebbetts about 1858, this house served as headquarters for both Confederate and Union troops during the Civil War. In early 1862, Gen. Benjamin McCulloch ordered Jonas Tebbetts arrested for treason and hanged at Fort Smith. McCulloch, however, was killed at the Battle of Pea Ridge, and Tebbetts was released. He and his family left Fayetteville soon after this. In 1968, the Washington County Historical Society acquired the house, pictured January 21, 1969, and maintains a museum and its offices there today. (Photograph by Charles Bickford, courtesy Shiloh Museum/WCHS Collection, P-344.)

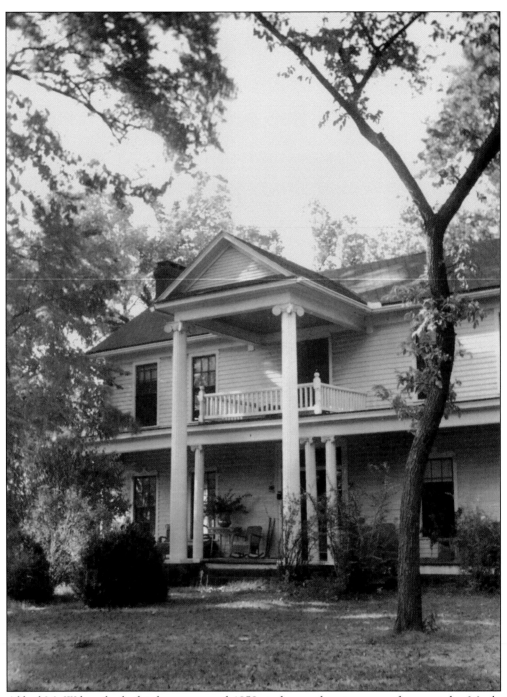

Alfred M. Wilson built this house around 1858 at the northeast corner of present-day Maple Street and Wilson Avenue. Five generations of Wilsons lived in the house, two of whom—Robert J. Wilson and Allen Wilson—served as mayor of Fayetteville. Part of the Wilson farm, which extended north to North Street, eventually became the city's first public park, Wilson Park. The house was razed in 1957 for the construction of the Pi Beta Phi sorority house. (Courtesy Shiloh Museum/WCHS Collection, P-366.)

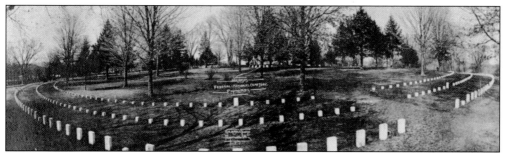

National Cemetery at Fayetteville, pictured in 1909, was one of 14 federal cemeteries authorized by Pres. Abraham Lincoln in 1862 for the burial of Union soldiers who died during the Civil War. The cemetery was established in 1867 south of town on a rise of land that had previously been called Gallows Hill because the county's gallows had been maintained there prior to the war. Since establishment, the National Cemetery has continued to expand to accommodate the graves of veterans of other wars. (Photograph by Burch Grabill, courtesy Charlie Alison.)

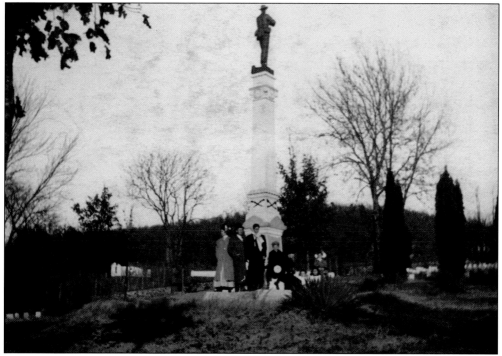

A group of women met on June 10, 1872, and organized the Southern Memorial Association with the intention of establishing a cemetery where Confederate soldiers who died during the Civil War might be buried. One year later, the Confederate Cemetery on the eastern end of Rock Street was dedicated, and the Confederate Monument was unveiled in 1897 on the 25th anniversary of the organization's founding. A group of people visit the Confederate Statue in this c. 1930s photograph. (Courtesy UA Libraries/WSC Collection, MC1427.)

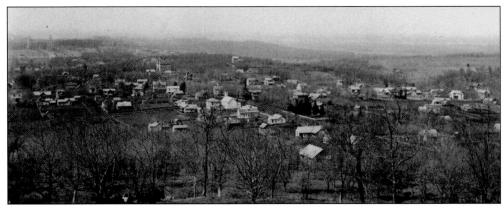

Fayetteville's first residential addition, the Masonic Addition, was built in the 1880s and 1890s. This 1892 photograph faced out from Mount Sequoyah and was probably taken from the hillside above present-day Fletcher Avenue. The church near the center of the picture is the St. Joseph's Catholic Chapel at the southeast corner of Lafayette Street and Willow Avenue. At the upper left is Old Main. The next large building to the right is the North School, site of present-day Washington Elementary. (Courtesy Charlie Alison.)

The home of Elizur B. and Sarah J. Harrison, pictured in the early 20th century, stood at the northwest corner of College Avenue and Lafayette Street. Harrison and his brother M. LaRue Harrison served as commanders of the First Arkansas Cavalry (Union) during the Civil War and settled in Fayetteville afterward. Elizur Harrison operated a hardware store on the square and started a wagon-manufacturing business called the Sweitzer Wagon Company. (Courtesy Shiloh Museum/WCHS Collection, P-367B.)

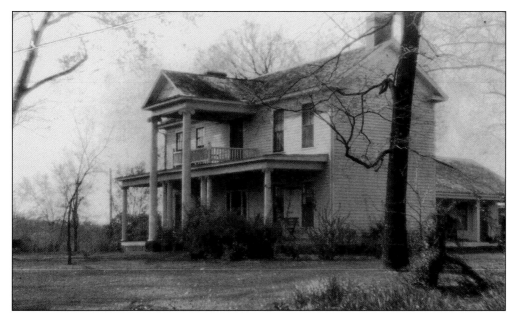

Joseph L. Dickson and Lelia W. Dickson built their home on a dirt road that marked the north side of the original plat of Fayetteville. The road eventually became one of the best-known streets in Arkansas—Dickson Street. The house, pictured in the early 20th century, stood until Central United Methodist Church built a new sanctuary on the site in 1953. (Courtesy Shiloh Museum/ WCHS Collection, P-405.)

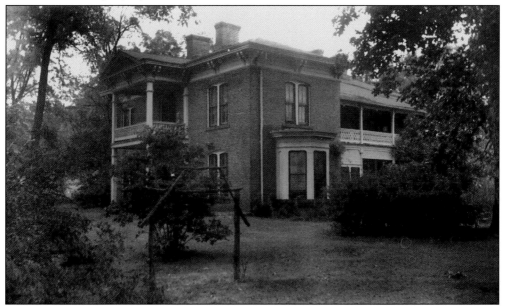

Justice David Walker built this house, pictured in the 1970s, at the eastern end of Knerr Drive on the site of Matthew Leeper's home, which burned during the Civil War. His daughter Mary and son-in-law James D. Walker lived in the house until their deaths. The Carl and Inez Knerr family bought the house in the early 20th century, and it is now owned by the Williams family. The Walker-Knerr-Williams House was added to the National Register of Historic Places in 1975. (Photograph by Mike Donat; courtesy Shiloh Museum/WCHS Collection, P-388A.)

23

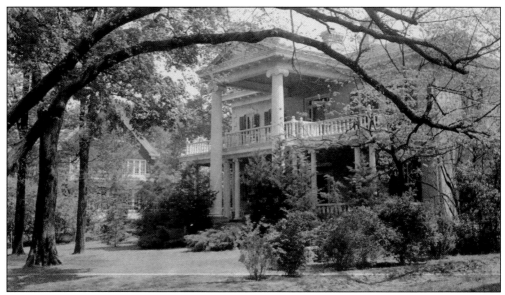

Erasmus I. "Ras" Stirman built the underlying structure of this house in 1868 on College Avenue near its intersection with Dickson Street. Over the years, the house was renovated, with columns and Greek Revival elements added by 1951, when this photograph was made. During the 20th century, it was the home of Annie Duke Futrall and John Clinton Futrall. The home was razed in the 1960s to make way for a car sales lot, and is now the site of the Washington County Courthouse. (Photograph by Walter J. Lemke; courtesy Shiloh Museum/WCHS Collection, P-376.)

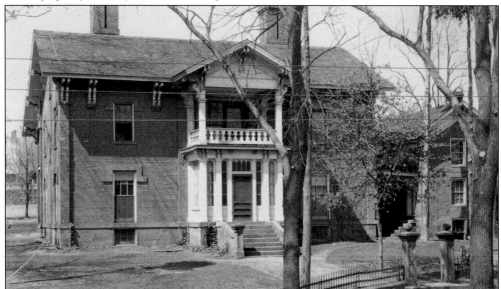

The home of Lafayette Gregg and Mary Shreve Gregg was built by 1871 on a block just east of what would become the University of Arkansas. Gregg wrote the legislation that located the university in Fayetteville, served on the university's board of trustees, and helped supervise construction of the university's main building, Old Main. The house, pictured in the mid-20th century, still stands at 339 North Gregg Ave. and is owned by descendants of the Greggs. It was listed on the National Register of Historic Places in 1974. (Courtesy Shiloh Museum/WCHS Collection, P-387A.)

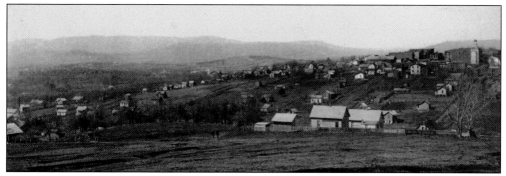

This c. 1892 photograph of south Fayetteville was taken approximately from the southern end of present-day Olive Avenue, looking west-southwest. The landscape extends from the white cupola of the 1870 Washington County Courthouse, right, marking the center of the Fayetteville square, to the smokestack of the White Mill at the lower extreme left. The hillside falling away, heavily wooded in earlier photographs, has been cleared and plowed under. (Courtesy Charlie Alison.)

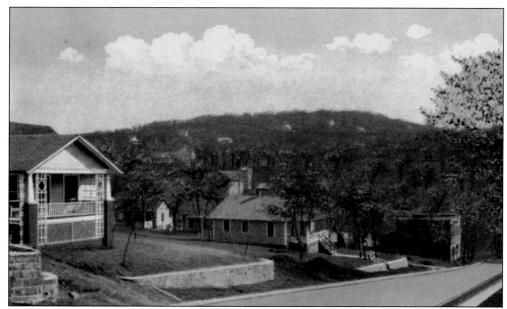

This postcard of Mount Sequoyah, taken about 1928 from almost the opposite angle as the picture above, shows Rock Street as it descends to Mill and Willow Avenues. The hillside of Mount Sequoyah is once again covered with trees. The two houses on the left side of Rock Street are still standing. The brick building at the bottom of the hill is no longer standing and is the approximate location of the Yvonne Richardson Recreational Center today. (Courtesy Charlie Alison.)

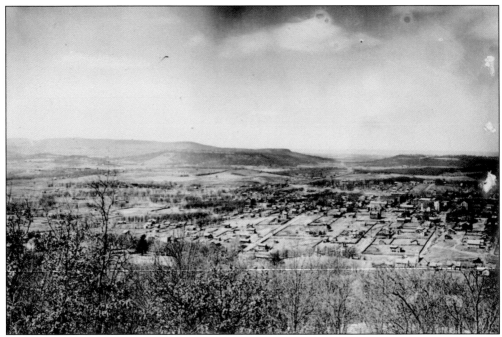

Burch Grabill took these two photographs of Fayetteville from Mount Sequoyah around 1903. The view above is of downtown Fayetteville and the south side of town. The steeples of both St. James Baptist Church and St. James African Methodist Episcopal Church are barely visible in the valley below, while the Washington County Jail and the Van Winkle Hotel can be seen at the crest of the hill. The view below looks northwest across the present-day Washington-Willow historic district toward Old Main. At the far right is North School, site of Washington Elementary School. (Both courtesy Shiloh Museum/WCHS Collection: above, P-489B; below, P489H.)

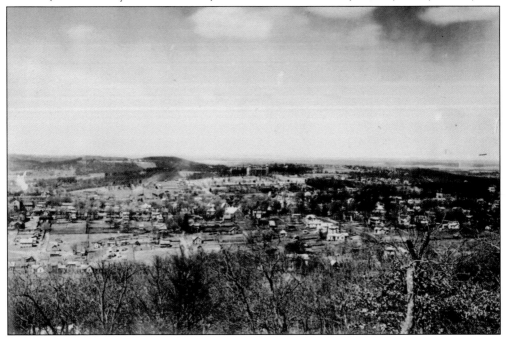

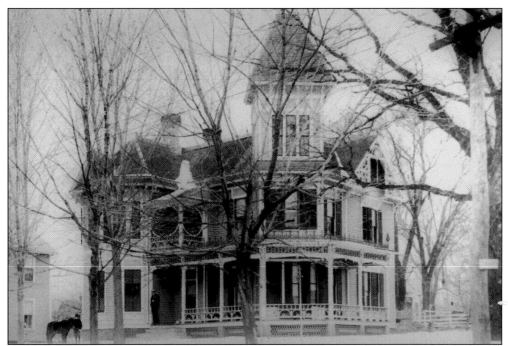

John A. Reed and Lena B. Reed made their home at 304 North College Ave., pictured around 1903. The building was razed in the mid-1960s to make way for construction of the Southwest Electric Power Company office. (Courtesy Shiloh Museum/WCHS Collection, P-1214.)

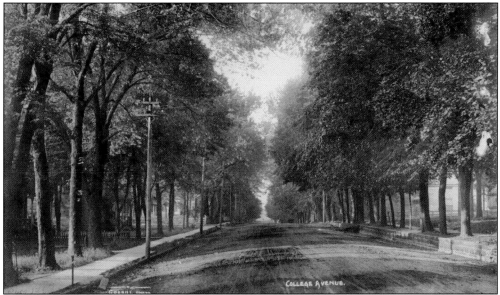

Originally known as the Cassville Road and occasionally referred to as the Springfield Road, College Avenue became the showcase of Fayetteville during the late 19th and early 20th centuries. The avenue, pictured in 1907, was lined with the city's grandest homes and churches and framed by an arch of maples, oaks, and elms. The character of the road changed during the 20th century, though, as more businesses opened, homes were removed, and trees were cut down. (Photograph by Burch Grabill; courtesy Shiloh Museum/WCHS Collection, P-489F.)

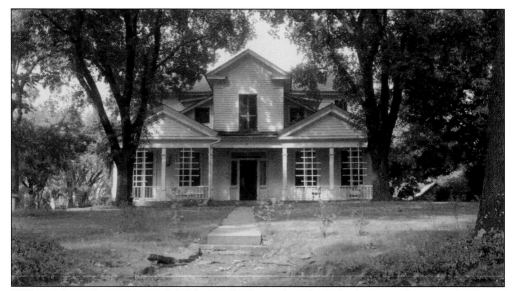

William Minor Quesenbury and Adaline Parks Quesenbury built this home on the west side of town in 1855, on present-day Duncan Avenue, south of its intersection with Center Street. Quesenbury was a poet, writer, editor, artist, cartoonist, soldier, and philosopher. He came to Fayetteville in the early 1850s to publish the *South-West Independent*, but left Fayetteville during the Civil War. Daniel Harvey Hill owned the house while he was president of the Arkansas Industrial University. The house, pictured around 1940, is no longer standing. (Courtesy UA Libraries/Lemke Papers, MSL541.)

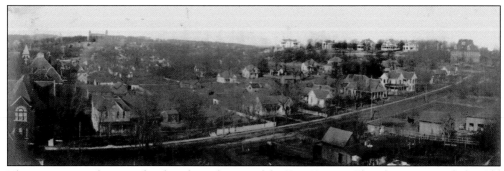

This panoramic photograph taken from the top of the First Baptist Church in 1908 includes Old Main on the western horizon, the houses of Mount Nord at right, and the Arkansas House at the left end of the row. In the early 1900s, W.H. Morton, J.E. Mock, E.C. Pritchard, and F.O. Gulley became interested in developing a block of land bounded by present-day Lafayette, Forest, Mock, and Maple Streets as a restricted residential section. (Photograph by Burch Grabill; courtesy Shiloh Museum/WCHS Collection, P-3827C.)

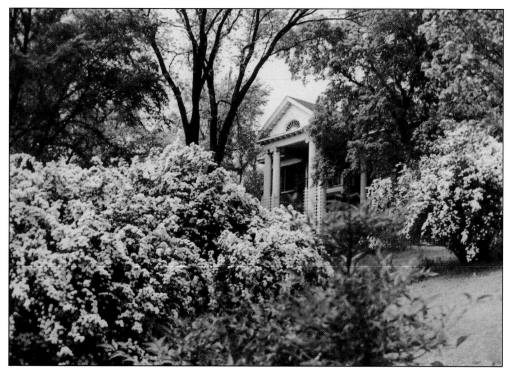

The Mock family built this brick house (above), which still stands atop Mount Nord. Later, the Fulbright family purchased it. To help terrace the hillside, a stone wall (below, around 1945) was built on the uphill side of Mount Nord Street. (Both courtesy UA Libraries/WSC Collection, MC1427.)

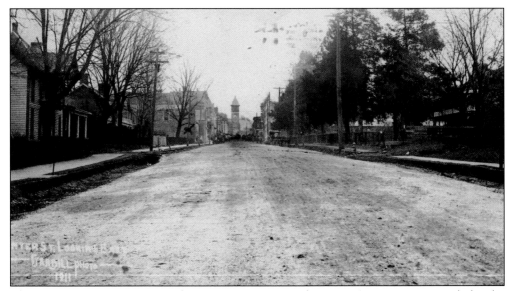

The view east on Center Street from its intersection with Locust Avenue in 1911 includes the Ridge House, built sometime in the late 1830s, at the immediate left, and the Reiff House, built in the 1850s, to its right. At the far right, among the trees, is the Walker-Stone House, built in 1847. All three buildings are still standing. The Ridge House is owned by the Washington County Historical Society and is leased for offices. The Reiff House is used by Moore's Funeral Home for its chapel and funeral arrangements. The Walker-Stone House is used for offices. (Photograph by Burch Grabill; courtesy UA Libraries/WSC Collection, MC1427.)

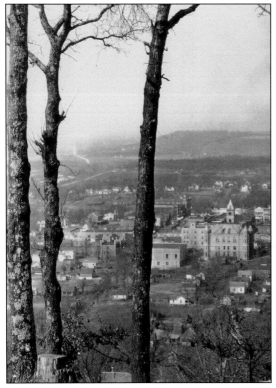

This view from East Mountain, now known as Mount Sequoyah, looks west-southwest across the city. Certain buildings in the photograph suggest the image was taken in the early 20th century. Today, the Mount Sequoyah Retreat Center's cross stands at the same location as these trees. (Photograph by Burch Grabill; courtesy Shiloh Museum/WCHS Collection, P-486A.)

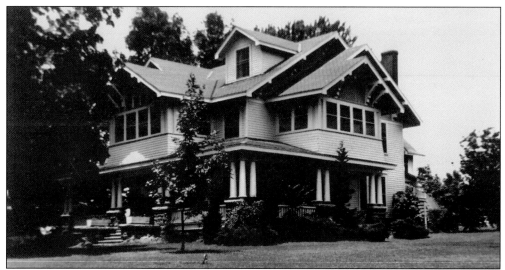

Joseph R. Bates and his first wife, Klyde Kelleam Bates, built this craftsman-style home near the crest of Maple Hill at 1404 West Cleveland St., then called York Street, sometime early in the 20th century. Joseph Bates operated Bates Brothers Grocery at 430 West Dickson St. (Courtesy UA Libraries/WSC Collection, MC1427.)

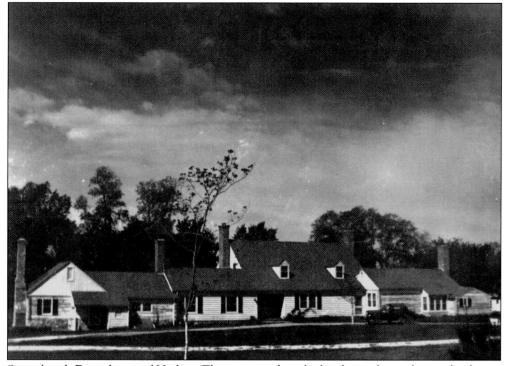

Springbrook Farm, home of Herbert Thomas, was described as being five miles north of town when this photograph was made around 1920. Today, the home, which is flanked by hand-hewn log rooms on the north and south ends, is part of the campus of the Washington Regional Medical Center. (Courtesy UA Libraries/WSC Collection, MC1427.)

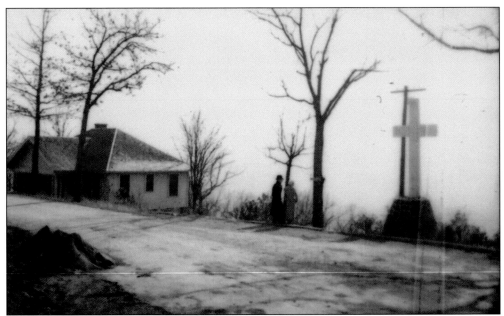

In 1908, some local businessmen considered developing the top of East Mountain, now called Mount Sequoyah. They proposed to build a women's college and platted a street called Skyline Drive that looped the southern knoll of the mountain. The college never came to be, but in 1920, the city offered more than 200 acres, including the knoll, to the Western Methodist Assembly as a place for its retreats and summer camps. Cabins and small summerhouses (below, around 1920) were constructed along the western side of the property for visitors to the Western Methodist Assembly. The Methodists also erected a cross (above) at the overlook of the city. Today, the grounds are called the Mount Sequoyah Retreat and Conference Center. (Both courtesy UA Libraries/Bennett Collection, MC1564.)

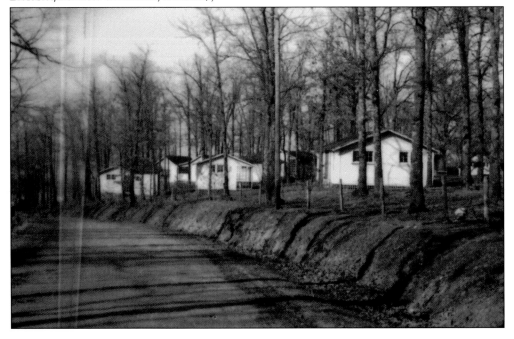

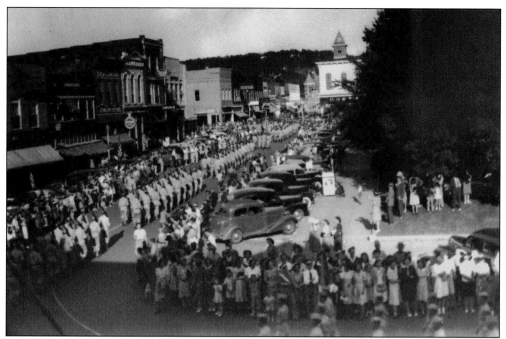

Troops march across the square after World War II during a parade to celebrate victory. The same block was used to promote blood drives and war bond drives while the country was at war. (Courtesy UA Libraries/WSC Collection, MC1427.)

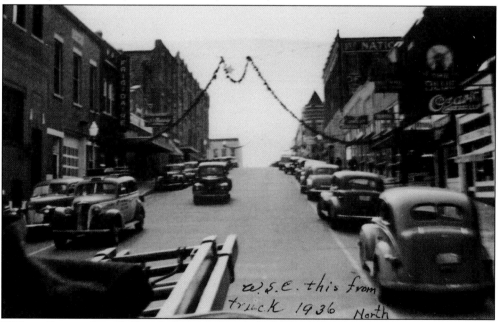

William Simeon Campbell took this photograph, looking south up Block Avenue, from the back end of a fire truck during the winter of 1936. The city fire station was at the left, just before the Frigidaire building and O.K. Milady Cleaners. On the opposite side of the street, Ozark Cleaners and the Blue Mill Café can be seen, along with the distinctive cone above the entrance to the Lewis Brothers Hardware Store. (Courtesy UA Libraries/WSC Collection, MC1427.)

In February 1912, the entire student body of the University of Arkansas went on strike to protest the expulsion of 31 students who had been involved in the printing of an underground newspaper called X-Ray. Despite being criticized by the student newspaper, local merchants sided with the protesters and put signs in their windows to show support. The students, seen here on Dickson Street, marched through town, held rallies at the Ozark Theater, and built fires on the lawn of Old Main, but they wouldn't go to class. Gov. George W. Donaghey eventually settled the conflict. (Courtesy Shiloh Museum/WCHS Collection, P-782.)

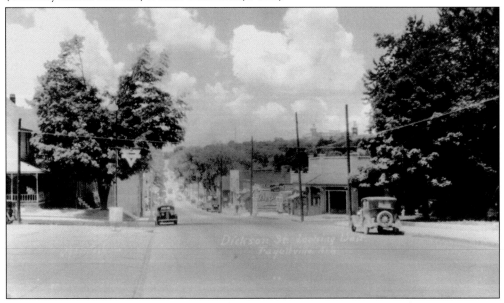

As late as 2000, the view down West Dickson Street at its intersection with Locust Avenue looked remarkably similar to this 1936 photograph. The automobile models have changed, but the house at the left, now the Dickson Street Inn, and the café at right, now the 36 Club, still stand, looking much the same. The street itself changed during the last decade when the city revamped the parking and sidewalks, adding trees, brick crosswalks, and landscaping. (Courtesy Shiloh Museum/WCHS Collection, P-466C.)

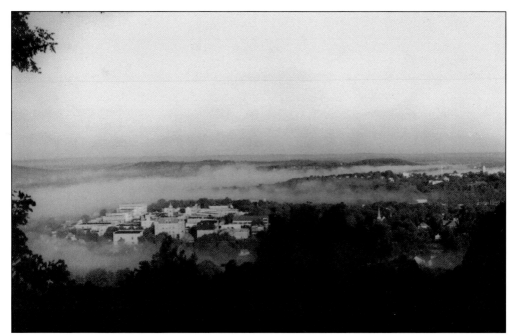

Morning fog turns the hills of Fayetteville into islands in this c. 1940 photograph, taken from Mount Sequoyah looking west across downtown at the lower left and extending to the towers of Old Main on the University of Arkansas campus at extreme right. (Photograph by Green Studio; courtesy UA Libraries/WSC Collection, MC1427.)

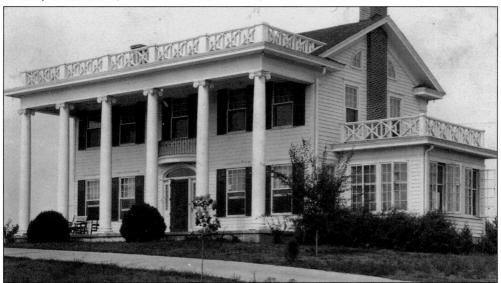

The Roy W. and May R. Williams home on Mount Sequoyah was captured in this c. 1945 photograph by William Simeon Campbell. Roy Williams, a great-grandson of William McGarrah, one of Fayetteville's early residents, started out driving trucks early in the 20th century. He moved quickly into insurance, loans, and real estate by the late 1920s, establishing the Williams-Rogers Agency with Yandell Rogers. Williams's financial success was such that he built this home, described at the time as the "most spectacular and imposing home in this section of the state" on the crest of Mount Sequoyah. (Courtesy UA Libraries/WSC Collection, MC1427.)

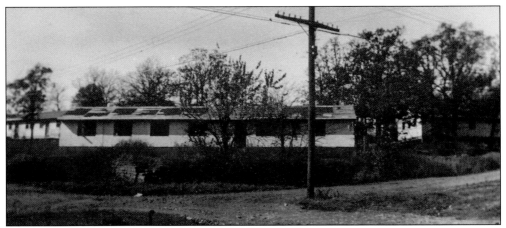

When World War II was over, housing was short for returning veterans who wanted to attend the University of Arkansas. While the university erected numerous temporary structures, private interests built seven barracks-style apartments and a manager's apartment near the northwest corner of Block Avenue and Fourth Street to accommodate the overflow. Some of these, since renovated, remain along Archibald Yell Boulevard. (Courtesy UA Libraries/WSC Collection, MC1427.)

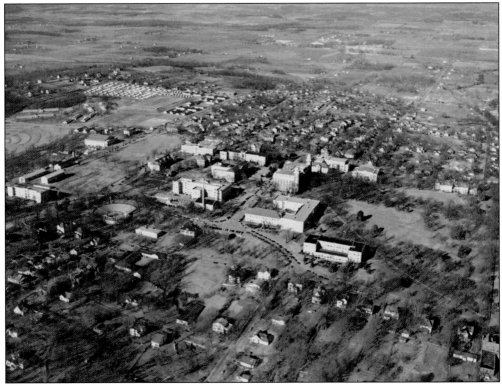

Looking north by northwest across the University of Arkansas campus about 1948, the stately homes along Dickson Street in the foreground contrast sharply with the small city of temporary student housing buildings to the upper left. In the 1960s, permanent student dormitories—Reid Hall, Fulbright Hall, and Hotz Hall—were built across the same hilltop. The university's newest residence halls—Maple Hill and the Northwest Quad—were added during the first decade of the 2000s. (Courtesy UA Libraries/WSC Collection, MC1427.)

Three

THE SEAT OF EDUCATION

The last diploma awarded by the Fayetteville Female Seminary went to Mary M. Stone, the daughter of Stephen K. Stone and Amanda M. Stone, who is pictured at the top of the diploma in 1861. The school was established in 1839 by Sophia Sawyer, a teacher among the Cherokee people who came west when the Cherokees were forced out of their ancestral lands in Georgia, Alabama, Tennessee, and North Carolina. Sawyer died in 1854, but the school was continued by Lucretia Foster Smith, who acted as principal until the Civil War ended operations. The school was used as a hospital after the Battle of Prairie Grove, but sometime in 1863, its main buildings were burned. (Courtesy Shiloh Museum/WCHS Collection, P-46.)

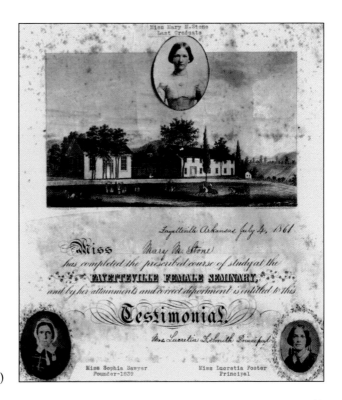

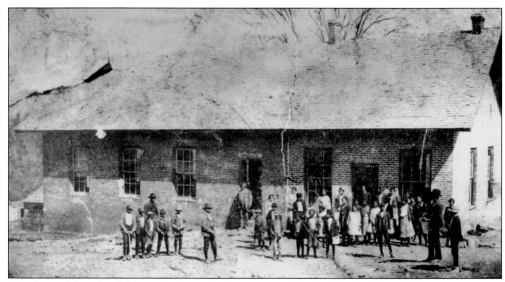

The first public school district in the state was organized at Fayetteville, and the first public school in the city was built for black students. Ebeneazor Enskia Henderson organized the district in 1866, and a school building (above) was erected in 1868 with help from the American Missionary Society, which purchased the property for the school from Lafayette Gregg for 1¢. First known as the Mission School, which lent its name to Mission Boulevard, the school was renamed Henderson School in 1907 in honor of superintendent Henderson and his daughter Clara Henderson, who taught at the school for many years. The dates of these two photographs are uncertain, although both appear to be from the early 1900s. Other early teachers included Dora Ford, Miss Manuels, A.L. Richardson, and W.J. Kidd. After Lincoln School was built in the 1930s, Henderson School was briefly used as a theater and then converted into a residence. Today, the building, though altered with the addition of log pens on either end, still stands as a private residence on Olive Avenue. (Both courtesy Shiloh Museum/WCHS Collection: above, P-14; below, P-16.)

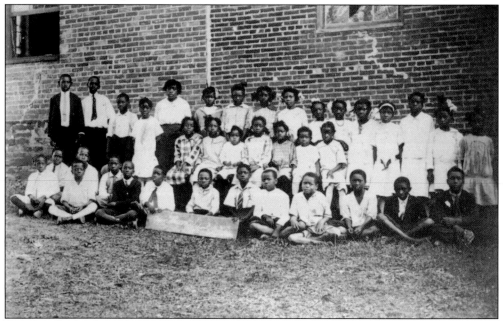

The North School (right, c. 1890s or early 1900s) was built in 1885 on the site of the current Washington Elementary School. It was Fayetteville's first public school for white children, the first grade of which is shown below sometime in the early 1900s. Within 15 years, two more public grade schools were built for white students, Jefferson Elementary at the corner of Church and South Streets, and then Leverett Elementary at the corner of Garland and Maple. (Both courtesy Shiloh Museum/WCHS Collection: right, P-7; below, P-66.)

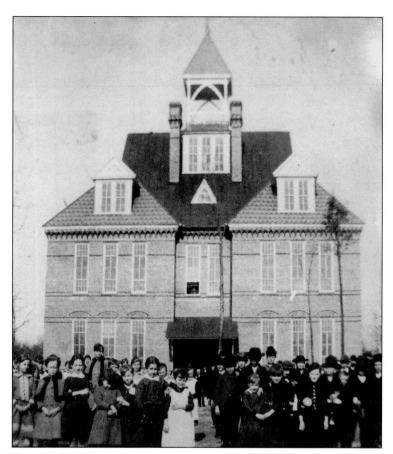

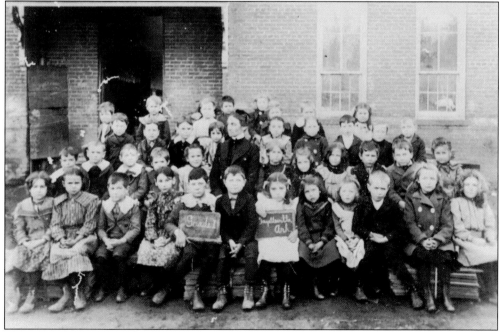

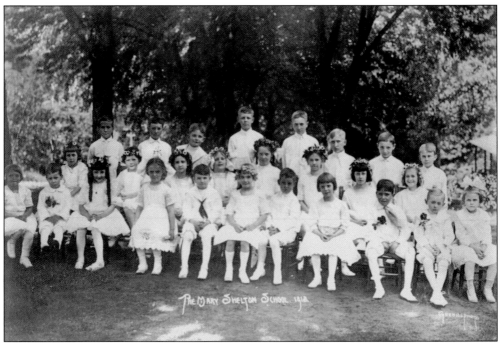

Mary Shelton began teaching in 1886 and opened her private school in 1911 at 223 East Dickson St. Shelton (below, at the back near the left) stands with her students in 1913 in front of the school. Students from the school pose for a spring photograph (below) in 1920. The house was razed to make way for construction of the Fulbright Library Building on Dickson Street. (Photograph above by Burch Grabill; both courtesy Shiloh Museum/WCHS Collection: above, P-10; below, P-77.)

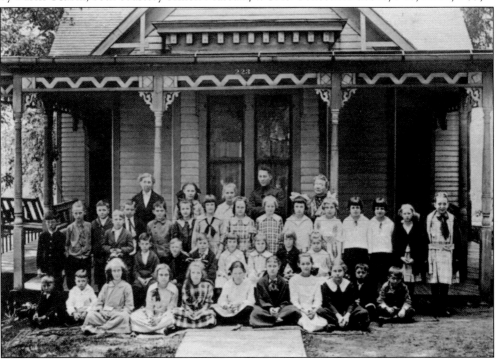

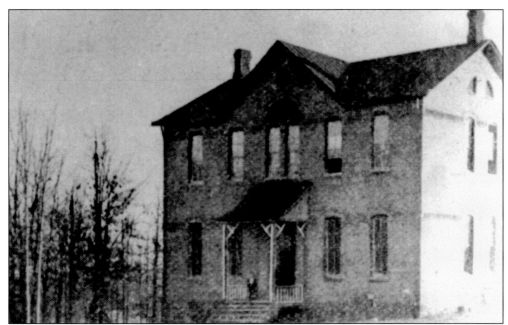

South School (above, sometime in the 1890s to 1904), later renamed Jefferson School, was built at the corner of Church and South Streets by contractor Albert M. Byrnes in 1891. The sixth-grade students (below) at Jefferson in the 1908–1909 school year included Carrie Williams, Everett Brinson, Anna Goldsborough, May Johnson Buxton, Lola Hodges, Miss Adams, Hugh Gonyer, John Kilgore, Claud Cheshire, Jesse Patterson, Harold Adams, Margie Deen, Lee Williams, Earl Pogue (or possibly Page), Jerome Thompson, Floyd Hodges, Ella Fincher, Odie Call, Nora Patterson, Susie Duncan, Roy Heuter, Ethel Pinebaugh, Alice Wright, Ben Strickler, Ollie Jarman, and Bert Clark. In addition to Jefferson School, Byrnes won contracts to build the next public school, Leverett, in 1899, and the school district's first high school in 1908. (Both courtesy Shiloh Museum/WCHS Collection: above, P-304; below, P-1071.)

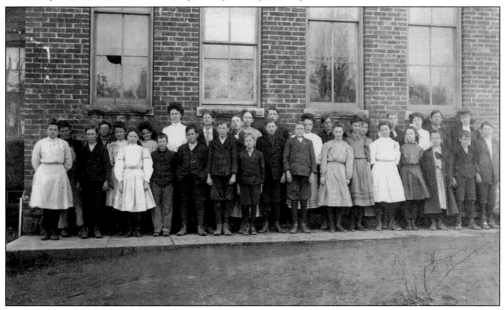

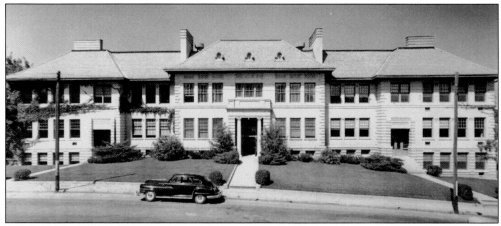

The Fayetteville School District built its first public high school in 1908 on the site of an early private school on School Street. In the 1920s, additions were built on the north and south ends of the building, shown in the 1940s. When the current high school was built on Stone Street in the mid-1950s, the old high school was converted to Hillcrest Junior High, which operated until the opening of Ramay and Woodland Junior Highs. The building was razed in the late 1960s, and Hillcrest Towers now occupies the site. (Courtesy Shiloh Museum/WCHS Collection, P-6B.)

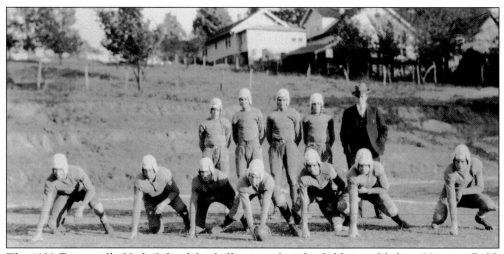

The 1930 Fayetteville High School football team takes the field, very likely at Harmon Field. The team, coached by Virgil Blossom, who later was superintendent of the Fayetteville School District before presiding over the troubled desegregation of Little Rock Central High School, had a difficult season, including its annual match with rival Springdale. The two teams went scoreless through the first three quarters of the game, despite good runs by the quarterback Scott Duskin and fullback Parker Rushing, before a Springdale player kicked a field goal in the final quarter, winning the game 3–0. (Courtesy Shiloh Museum/WCHS Collection, P-147.)

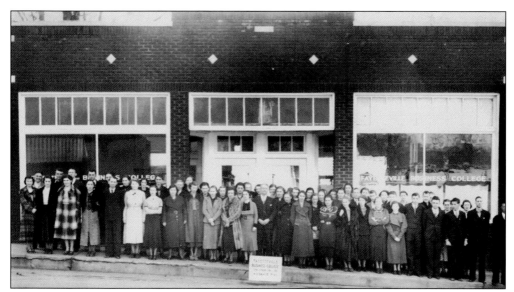

Students of the Fayetteville Business College stand in front of the building in the 1930s. The Fayetteville Business College advertised itself as "the school you'll like" and was started in 1905 by L.W. Newcomb and H.A. Franz on the second floor of the Wolf Building on Mountain Street. H.O. Davis acquired the college not long after arriving in Fayetteville in 1919 and moved it to the 300 block of Dickson Street by 1935. At its height during the 1920s, more than 300 students enrolled each semester. The college operated in this location until 1973. It moved to 221 Locust Ave. and closed in 1978. Today, the building is home to Emelia's Restaurant. (Courtesy Shiloh Museum/WCHS Collection, P-2742.)

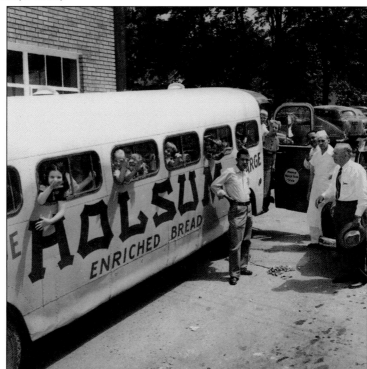

In the early 1950s, Shipley Baking Company used a bus, painted to look like a loaf of Holsum bread in its wrapper, to bring students for tours of its bakery on Dickson Street. (Courtesy UA Libraries/Shipley Baking Company Collection, MC954.)

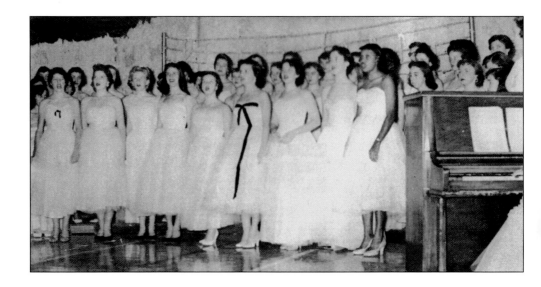

After the US Supreme Court decided in *Brown v. Board of Education* in 1954 that separate education was inherently unequal, the Fayetteville School Board voted to integrate its high school. This and two other Arkansas school districts became the first in the south to integrate when the schools reopened the next fall. Black students, however, often faced the prospect of being the only student participating in a particular club, competing on an athletic team, or simply attending class. Peggy Taylor (above, right) sings in the girls' chorus during the school's Christmas convocation in 1955. Joe Manuel (below) competed alongside white students, but the Fayetteville football team was shunned by some school districts that wouldn't compete against a team with African American players. Other African American students who played on the team included William Lee Hayes and James Funkhouse. (Both courtesy the Fayetteville School District.)

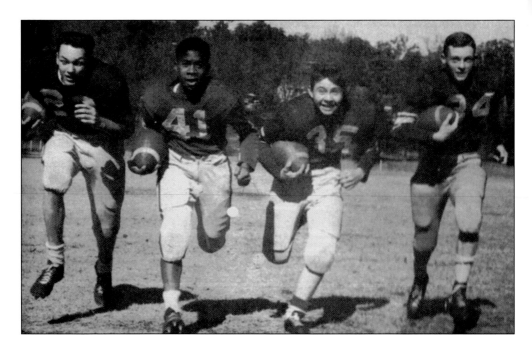

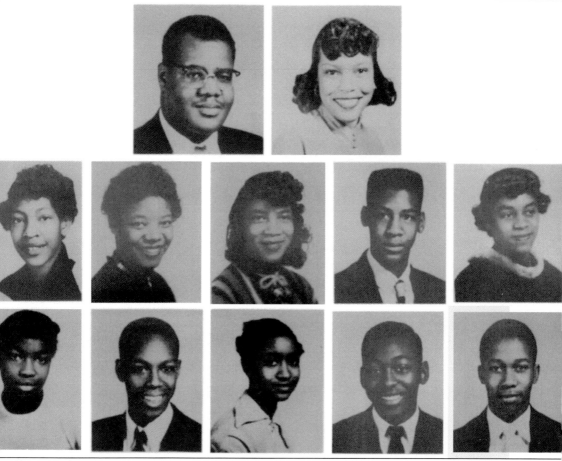

Seven black students—two juniors and five sophomores—entered Fayetteville High School in the fall of 1954. They faced an overwhelmingly white student body. Although teachers, guidance counselors, and administrators developed programs to reduce friction between white and black students, the small coterie of black students relied on each other for moral support. Included in the student body the following year were, from left to right, (first row) sophomores Loretta Blackburn, James Funkhouse, Pauline Conley, William Lee Hayes, and Joseph Manuel; (second row) juniors Mary M. Blackburn, Roberta Lackey, Elnora Lackey, Kenneth Morgan, and Virginia Smith; (third row) seniors Preston Lackey and Peggy Ann Taylor. They were 12 black students among a student body of more than 450. (Courtesy the Fayetteville School District.)

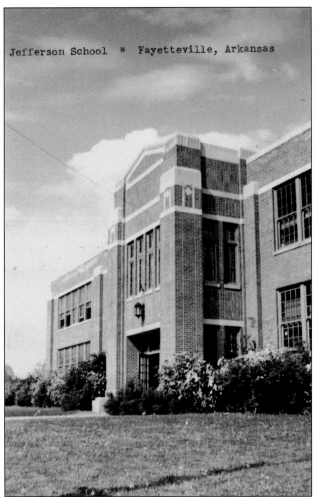

Jefferson School * Fayetteville, Arkansas

The second Jefferson Elementary School (left) was built around 1930 on South College Avenue between present-day Martin Luther King Boulevard and Seventh Street. Bessie M. Coventon was the principal. The surrounding land, mostly agricultural, developed slowly over the next three decades. A minor building boom occurred in the 1940s after World War II. Small, affordable homes such as the brick and stone bungalow below, located at 17 West Martin Luther King Jr. Blvd., were erected. Arthur C. Caselman, an engineer for the city water department, and Gladys S. Caselman lived in the house from 1951 to the late 1970s. The house under construction to the right is at the southeast corner of Martin Luther King Jr. Boulevard and Block Avenue. Both buildings are still standing. Jefferson Elementary is now used by the Fayetteville School District for its adult education classes. (Both courtesy UA Libraries, University of Arkansas/ WSC Collection, MC1427.)

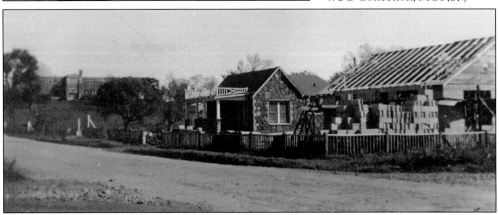

Four

THE CENTER OF
COMMERCE

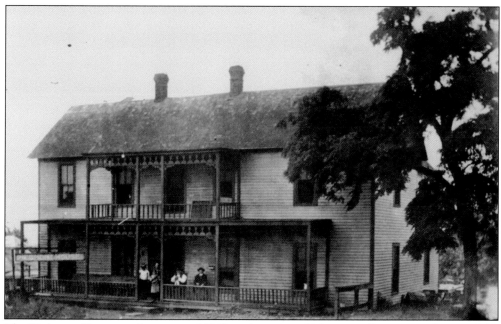

The Piedmont House, at the corner of College Avenue and Mountain Street, now the site of the John Paul Hammerschmidt Federal Building, was frequently used to house jurors because of its proximity to the courthouse. A "popularly priced" boardinghouse, according to William Campbell's history *One Hundred Years of Fayetteville: 1828–1928*, the house stood until construction of the federal courthouse in the late 1960s. The house is pictured around the early 1900s. (Courtesy Shiloh Museum/WCHS Collection, P-331.)

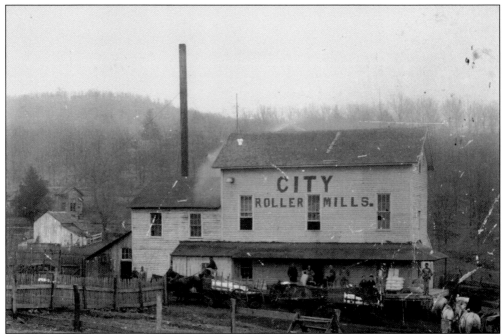

After the Civil War, Alexander Hendry rebuilt the mill, pictured in the 1900s or 1910s. It was officially named the City Roller Mill because it included one single and three double sets of California rollers for milling flour, but residents tended to call it the White Mill because of its whitewashed color. Today, the Happy Trails Motorcycle Connection store operates a Harley-Davidson dealership at 224 South Mill Ave., on the old site of the mill. (Courtesy Shiloh Museum/ WCHS Collection, P-341.)

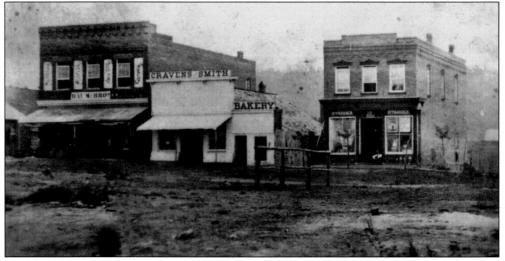

In 1865, the brothers Baum—Leopold, Joseph, and Moses—made the journey from St. Louis to Fayetteville to open a dry goods store on the east side of the Fayetteville square. Alongside Baum Brothers' two-story brick building was the Cravens Smith general store, operated by J.L. Cravens and Pressley Smith, with Johnny Fosfender's Bakery tucked in next door. Next to them, S.F. Paddock reopened his drugstore after the Civil War, on the south end of the block at the same site as his original store. (Courtesy UA Libraries/McIlroy Bank Collection, MC890.)

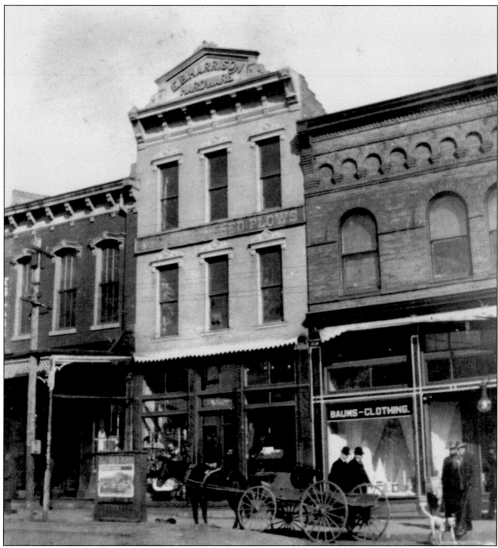

The E.B. Harrison Hardware store, pictured in the 1890s or early 1900s, was in the middle of the block on the east side of the square. Elizur B. Harrison, who came to Fayetteville as part of the Union forces that occupied Fayetteville from 1863 onward, settled in Fayetteville after the war and opened his hardware store, selling plows next door to the popular Baum Brothers. (Courtesy Shiloh Museum/WCHS Collection, P-132.)

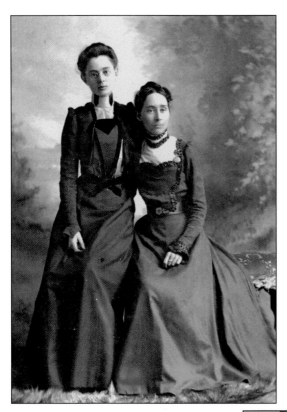

Lola Ellis and Maggie Jackson (left, pictured perhaps in the early 1890s) were the first telephone operators for the Fayetteville Telephone Company when it opened in 1895. Ellis (below, in the 1940s or 1950s) continued to work as an operator through most of the first half of the 20th century and recalled that when phone numbers were being assigned to new customers, a woman refused to take no. 13, so William N. Gladson, who had started the company, took it as his own number. (Photograph left by C.E. Watton; both courtesy Shiloh Museum/WCHS Collection: left, P-906; right, P-901.)

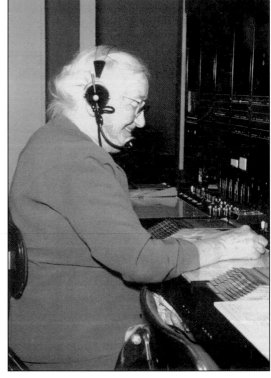

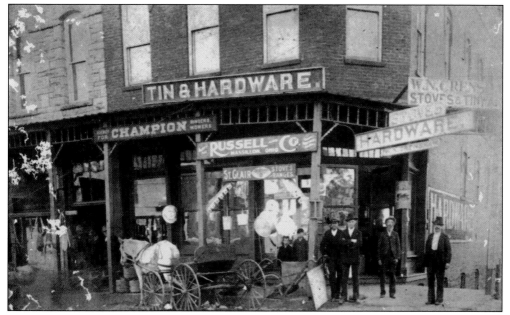

W.N. Crenshaw owned and operated Crenshaw Hardware (pictured around 1900) at the southeast corner of the square. Crenshaw, who came to Arkansas during the Civil War as a member of a Louisiana regiment, settled in Fayetteville after the war. He started in business as a tinner and expanded to hardware. His family lived at 534 North Willow Ave. (Courtesy Shiloh Museum/WCHS Collection, P-135.)

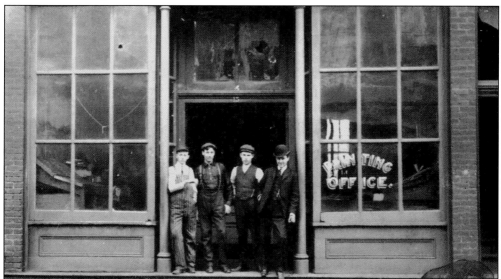

M.W. "Mack" McRoy (right) started the McRoy Printing Company around 1900. Pictured with him about that year are two unidentified men and E.A. "Boge" Bridenthal (second from left). The printing office continued at 15 East Center St. until 2005, when the business, by then known as McRoy-McNair, closed its doors. It was among the oldest continually operating businesses in Arkansas at the time, and Linotype machines in the basement were among the last fixtures to be removed from the building before it was converted into condominiums and offices. (Courtesy Shiloh Museum/WCHS Collection, P-265.)

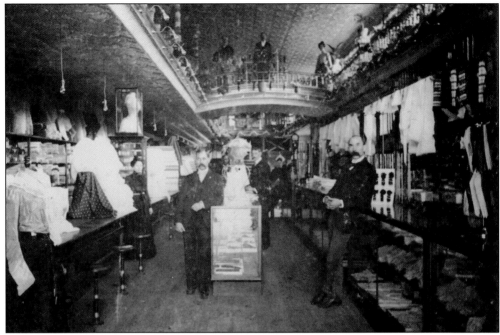

The McIlroy Dry Goods Company operated at the eastern end of the north side of the square. Its interior is pictured as it looked in 1905. Employees included, from left to right, Miss Jackson, Mr. Cannon, Charles Blanchard, and C.H. Oates. Miss Pulley is on the balcony to the right. (Courtesy Shiloh Museum/WCHS Collection, P-314.)

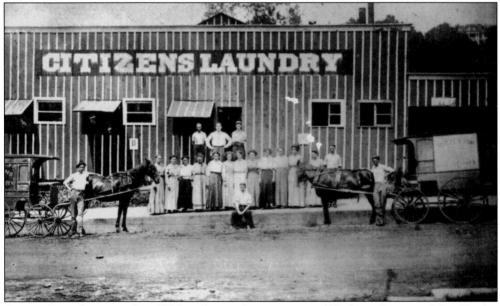

Citizens Laundry opened in 1908 at the northwest corner of Dickson Street and St. Charles Avenue, the site of the present-day Collier's Drugstore. Bill Dunn (standing with the two other men nearest the door, to the far right) purchased an old skating rink and converted it into one of the city's most successful cleaners. (Courtesy Shiloh Museum/WCHS Collection, P-307.)

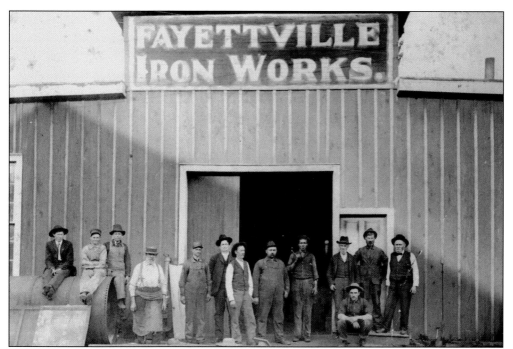

Phillip Barringer operated the Fayetteville Iron Works and Machine Shops at the corner of West Avenue and Watson Street during the early part of the 20th century. This photograph is from around 1916. (Courtesy Shiloh Museum/WCHS Collection, P-308.)

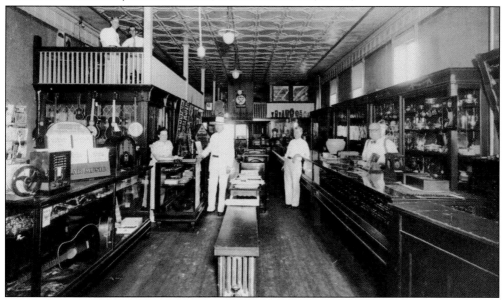

Ivan W. Guisinger opened a music store on the square in 1905, operating on the southeast corner by the time this 1924 photograph was taken and continuing in operation until the 1980s. Included in this photograph are, from left to right, (on balcony) Mr. Baker, a salesman from Little Rock, and Ivan Guisinger; (downstairs) Grace Pool, unidentified, Paul Guisinger, and George Parsons. It was one of the longest-operated family businesses on the square. (Courtesy Shiloh Museum/ WCHS Collection, P-320.)

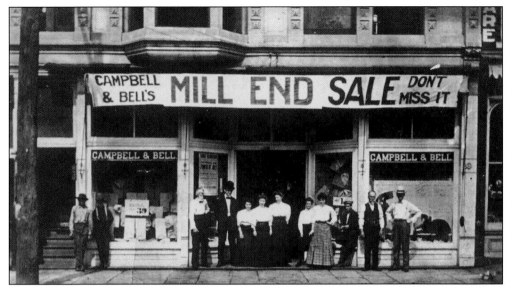

The wooden sidewalk in front of Campbell and Bell Dry Goods Company would soon be crowded with shoppers, and the employees, pictured in the summer of 1905, would be busy with the shop's mill end sale. Started by A.J. Campbell and Joe Bell during the late 19th century, Campbell and Bell Dry Goods Company operated for nearly a century at this site on the west side of the Fayetteville square. The building still stands, though it was significantly altered during renovation in the 1990s. (Courtesy UA Libraries/WSC Collection, MC1427.)

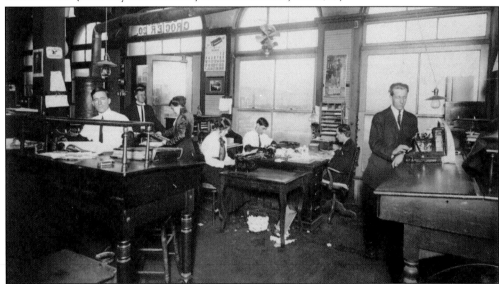

Manager Fred Borden (right) stands in the offices of the Ozark Grocery Company in March 1918. The company was the largest wholesale grocery house in the region, importing a variety of foods by railcar, which arrived at its loading docks on West Avenue. A.J. Rhea built the sandstone building in 1886 at the southwest corner of Dickson Street and West Avenue. He sold his interests in the early 1890s to the Fayetteville Grocery Company. The company changed the name to Ozark Grocery Company in 1907 when it bought Conner Wholesale Grocer. In its last years, the building was used by Ruble Transfer and Storage. It burned in 1974. (Courtesy Shiloh Museum/WCHS Collection, P-336.)

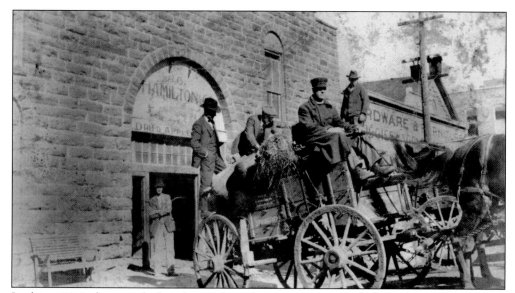

In this c. 1910 photograph, fruit buyers from St. Louis stop at the A.C. Hamilton Company to purchase dried apples and load them into a Springfield wagon. Hamilton's company was on the north side of Center Street between Block and Church Avenues. During the late 19th century and first half of the 20th century, the region surrounding Fayetteville was one of the biggest producers of apples in the country, giving rise to canneries and evaporating plants such as Hamilton's. Most of the product was shipped out of Fayetteville to eastern markets. (Both courtesy UA Libraries/ WSC Collection, MC1427.)

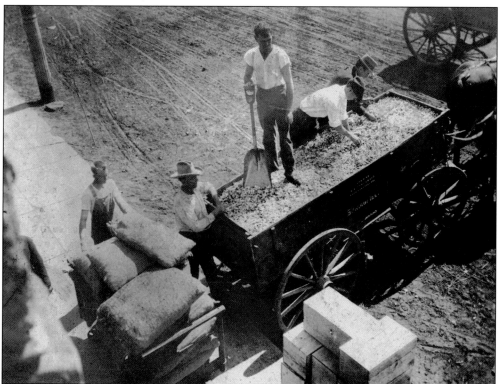

Alpha L. Goss began offering service for "anything electrical" prior to 1920 with an office on Block Avenue. By about 1927 when this photograph was made, he was in partnership with Lee H. Rogers, and the name of the business had changed to the Goss-Rogers Electric Company. (Courtesy Shiloh Museum/WCHS Collection, P-21.)

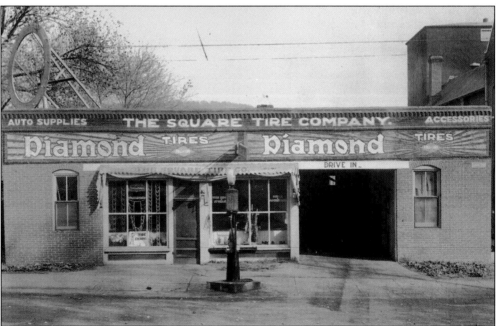

In advertising its sale of the Diamond Tires brand, the Square Tire Company of Fayetteville may have left customers in the 1920s wondering whether round tires could be had. The Square Tire Company operated at 17 West Mountain St. in 1920, one of a growing number of retail stores dedicated to automobiles. (Courtesy Shiloh Museum/WCHS Collection, P-309.)

The Edward Green Building was erected in 1913 at 401 West Dickson St., site of the present-day Walton Arts Center. James F. Winchester, pictured in October 1941, opened a grocery downstairs. On the second floor, H.M. Scott operated "a European-style hotel." The Scott Hotel became very popular with traveling businessmen because of its close proximity to the Fayetteville railroad depot. By the 1960s, the building (below) had become rundown. The upstairs was turned into a flophouse, although the first floor continued to be used for offices, such as the headquarters for the Washington County Republican Party in 1968. The building was razed in 1969. (Photograph at right by *Northwest Arkansas Times*; both courtesy Shiloh Museum/WCHS Collection: right, P-2446; below, P-340.)

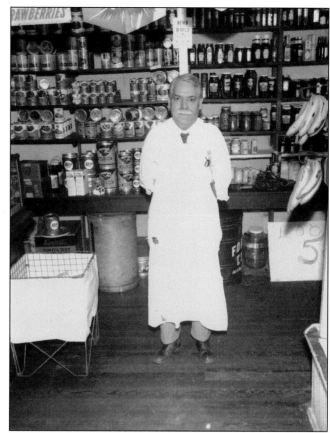

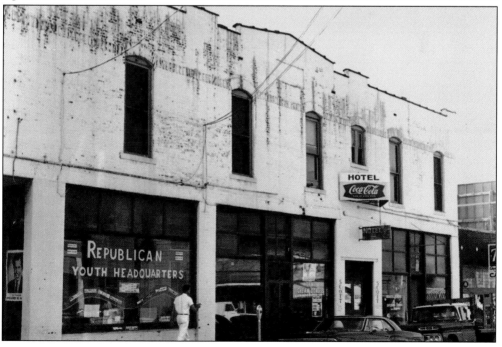

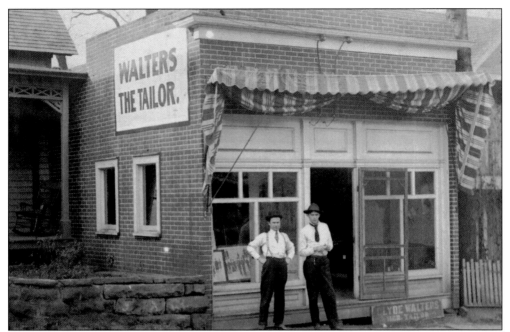

Clyde Walters, left, pictured sometime during the 1910s, operated a tailor shop at 107 North Block Ave., not a bad location as it was less than a block from the Fayetteville firehouse, where Walters also served as fire chief in 1924. His tailor shop was at the location of Ozark Cleaners today. (Courtesy Shiloh Museum/WCHS Collection, P-471.)

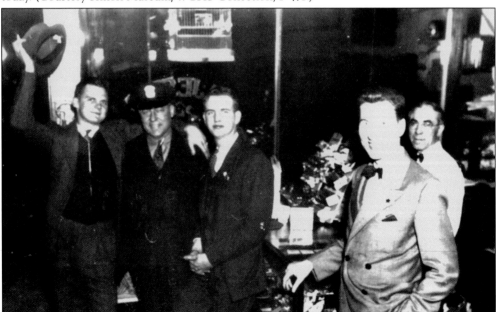

On February 1, 1927, George Pappastavian, Theodore Kantas, and John Tellas opened the Majestic Café in a little brick structure at 519 West Dickson St., on the site of the old Lewis and Sharp Mercantile. Patrolman Theo Burns (center) and Pappastavian (behind counter) are pictured with students in the late 1920s or 1930s. By 1947, when Mary Hinton purchased the business, it was known as George's Majestic. (Courtesy Shiloh Museum/WCHS Collection, P-805.)

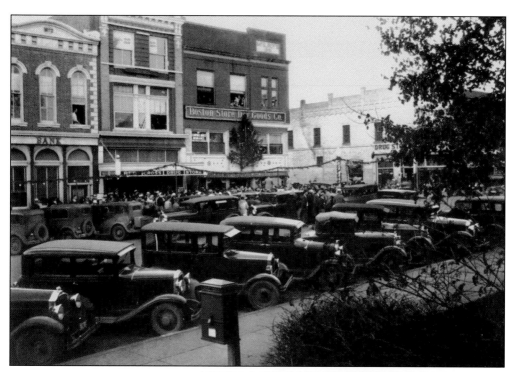

At Christmastime in the early 1930s, the Boston Store (above) was to Fayetteville what Macy's was to New York City. After the store burned in 1932, the Boston Store rebuilt on the site. Betty Ruth Nix (right) models the newest fall outfit at the entry to the new store in September 1941. Located at the eastern end of the north side of the square, the Boston Store stayed at the location from 1925 to 1972, when it moved to the newly opened Northwest Arkansas Mall. (Photograph at right by the *Northwest Arkansas Times*; both courtesy Shiloh Museum/WCHS Collection above, P-120; below, P-2466.)

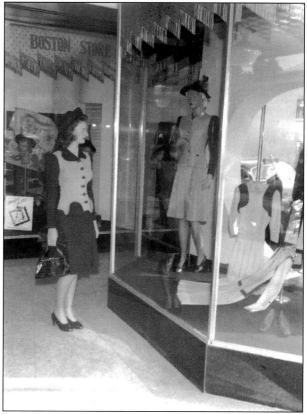

The Industrial Finance Building on Center Street, pictured in 1929, was constructed on the site of the old Mountain House boardinghouse, later operated as the Oriental Hotel. The Mountain Inn later acquired the property and used most of the building for its hotel rooms and restaurant, although other businesses opened on the ground level. The building is still standing and houses restaurants and offices. (Courtesy Shiloh Museum/WCHS Collection, P-264.)

Roy Scott operated the Arcade Barber Shop, pictured in July 1930, at 37 East Center St. in the newly built Industrial Finance Building. He opened the business about 1930 and continued into the 1940s. Even after the barbershop ceased operations, the building was referred to as the Arcade Building for the next two decades. Scott served as mayor of Fayetteville during the latter part of the 1950s. (Photograph by McIntosh Studio; courtesy Shiloh Museum/WCHS Collection, P-460.)

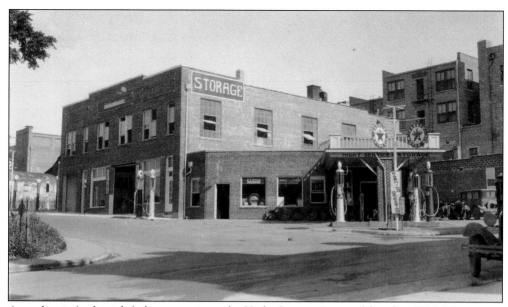

A mechanic (at far right) changes a tire at the Hight Service Station (above) in 1930. The station and the Hight Building to its left were built in 1930 at the northwest corner of College Avenue and Mountain Street on what had been a livery and stables. The Mountain Inn on Center Street bought the corner in 1957, building a modernist addition to its hotel (below) and renaming itself the Mountain Inn Motor Lodge around 1960. The hotel added 64 guestrooms, a swimming pool on the fourth floor, and a parking deck, reflecting the shift to catering to automotive travelers. The modern portion of the Mountain Inn fell into disrepair during the 1990s and was razed in 2003 to make way for the construction of a new hotel; however, plans for the new hotel fell through during the 2008 economic downturn, and the site was turned into a parking lot. (Above, courtesy Shiloh Museum/WCHS Collection, P-339; below, courtesy Charlie Alison.)

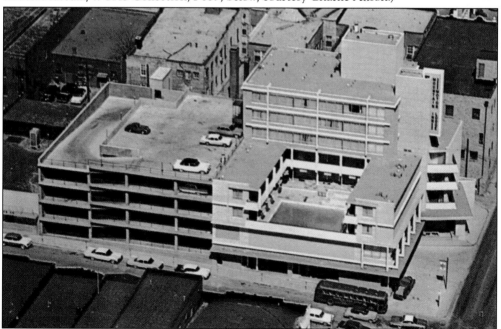

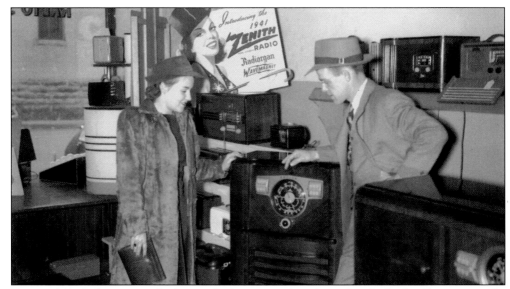

Two unidentified customers look over the latest Zenith radio at Smith's Radio Shop, posing for a photograph in April 1941. Layman A. Smith worked in the radio department of Guisinger's Music Store during the 1930s and opened his own store, Smith's Radio Shop, in the late 1930s at 11 East Mountain St., just four doors down the street from Guisinger's. Smith stayed at the location for nearly 20 years and moved his operation to 520 North College Ave. about 1957, where it remains in business. (Photograph by *Northwest Arkansas Times*; courtesy Shiloh Museum/ WCHS Collection, P-2481A.)

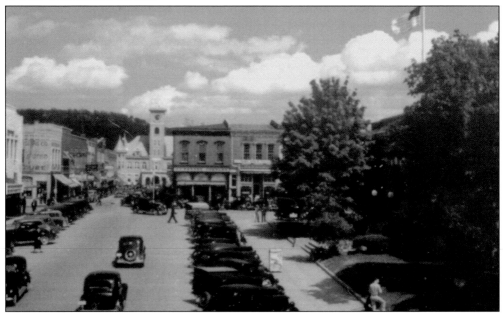

By the time this photograph was taken in the 1930s, the J.C. Penney Company had opened on the northern end of East Avenue on the square, the spot long kept in business by the Stone family. J.C. Penney moved to the south side of the square in the 1940s, where it remained until 1977, after which it joined the exodus of retail stores to the Northwest Arkansas Mall. (Courtesy UA Libraries/Bennett Collection, Sheet 55.)

Installation of natural gas lines across the city meant that homes with coal-fired furnaces or wood-burning stoves could convert to a relatively inexpensive and safer method of heating, including this small house in south Fayetteville. (Courtesy UA Libraries/WSC Collection.)

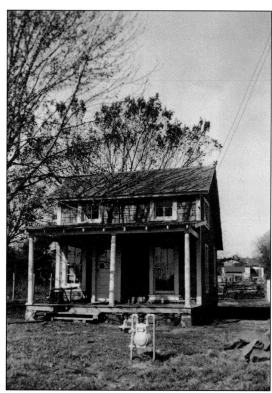

Three employees of the Arkansas Western Gas Company—Arnold Christie, Paul Bond, and Basil Gann—pose on March 25, 1942, behind the company's office, which was at 34 East Center St. during that period. Leonard Baxter was general manager of the Fayetteville operation. Meter readers used bicycles to canvas customers' homes to assess gas usage for billing. (Photograph by the *Northwest Arkansas Times*; courtesy Shiloh Museum/WCHS Collection, P-40.)

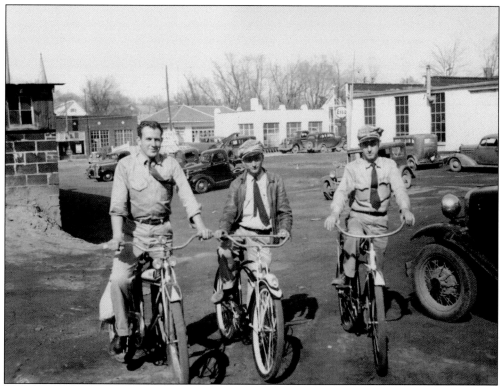

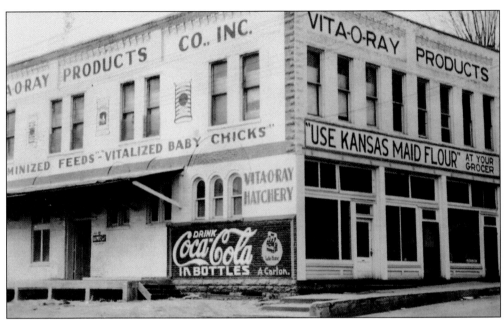

The Vita-O-Ray Milling Company and Hatchery operated at 603 West Dickson St. from 1939 to 1948 with Ishmael G. Fullington as president. The building then became Polk's Furniture and later was home to Sound Warehouse for a period. Today, the building is split into a Qdoba Restaurant on the first floor and a private residence on the upstairs floor, with office space in the basement. (Courtesy Shiloh Museum/WCHS Collection, P-306.)

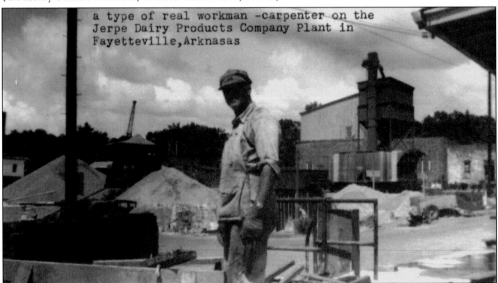

A carpenter pauses for this c. 1940 photograph while working on an addition to the Jerpe Dairy Products Company's plant, just out of sight to the right. It was southwest of Spring Street and West Avenue. The sand and gravel operation in the background continued into the 1980s but was covered over in the 1990s to make the Walton Arts Center parking lot. Today, the larger of the two buildings beyond the sand elevator holds Grubb's Restaurant. To its right is the building that held Porter Produce for many years and is used as a studio for several artists now. The Jerpe Dairy Building is used for restaurants and service-oriented businesses. (Courtesy UA Libraries/WSC Collection, MC1427.)

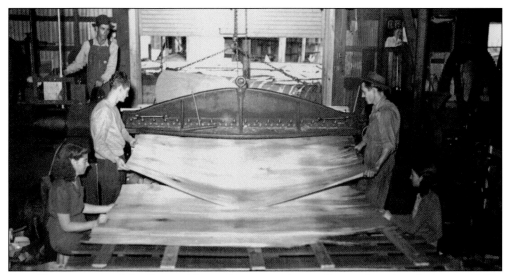

Perry Brower operated the Brower Veneer Company plant at Fayette Junction during the 1920s. Employees are pictured in November 1942 unloading mahogany veneer to be used for finishing products as diverse as firearms and airplanes. Standing at back, operating the rotary mill, is Tommy Gibbs. The other employees pictured are, from left to right, Waneta Smith Redfern, Ervin Osborn, Bruce Baucum, and Linda Evans. The company was one of many lumber-related businesses that developed in Fayetteville as the hardwood forests of the Ozarks were cut down and shipped out by freight. (Photograph by *Northwest Arkansas Times*; courtesy Shiloh Museum/ WCHS Collection, P-2545B.)

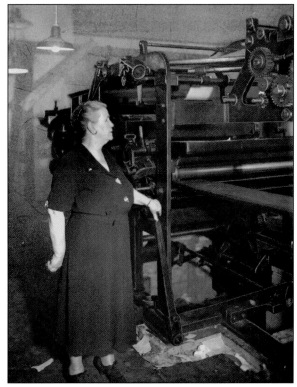

Mabel Inez Gearhart Edgington, a proofreader for the *Northwest Arkansas Times*, stands next to one of the press units as the paper printed on February 5, 1940. Started in 1868 as the *Fayetteville Democrat*, the *Northwest Arkansas Times* continued under local ownership until the late 1960s, when it was sold to Thomson Newspapers. The newspaper eventually ended up in the hands of WEHCO Media, publisher of the *Arkansas Democrat-Gazette*, and merged with the *Morning News* in 2008. (Photograph by *Northwest Arkansas Times*; courtesy Shiloh Museum/ WCHS Collection, P-470.)

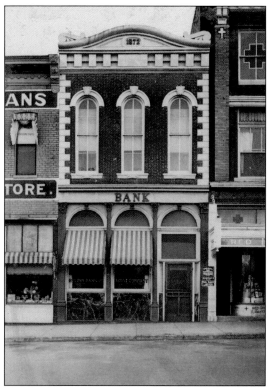

For nearly 100 years, the tall, skinny building on the south side of the square was home to McIlroy Bank. It started out as the Stark Bank, founded by Denton Stark with William McIlroy as a partner. Stark, however, left town rather quickly in 1875 after overextending his financial resources. McIlroy took over the building and reopened the bank as McIlroy Bank in January 1876. The building remained until the early 1970s, when the eastern end of the block was razed, and a new McIlroy Bank was built on the site. (Courtesy UA Libraries/McIlroy Bank Collection, MC890.)

Tellers and customers pose for a photograph in the main lobby of McIlroy Bank in 1939, decorated for the holiday season. (Courtesy UA Libraries/McIlroy Bank Collection, MC890.)

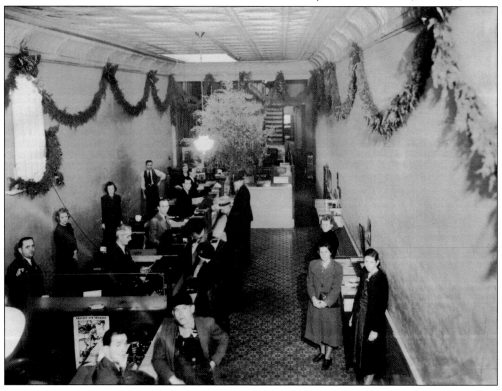

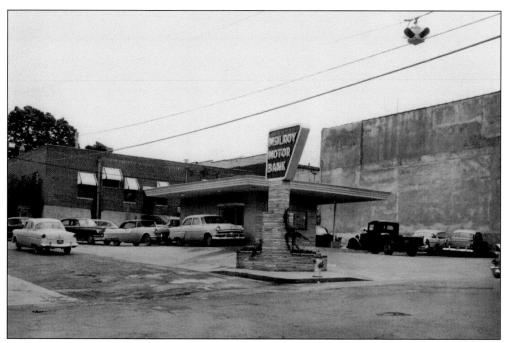

McIlroy Bank opened the area's first drive-through branch bank at the southeast corner of Meadow Street and Block Avenue. (Courtesy UA Libraries/McIlroy Bank Collection, MC890.)

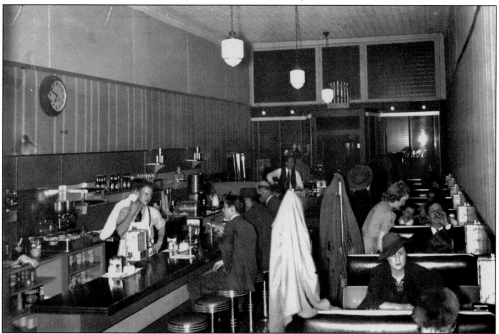

Restaurateur Ralph Ferguson opened the Blue Mill Sandwich Shop, pictured in February 1941, at 23 North Block Ave. in the mid-1930s, and operated it until the late 1940s. He left to open Ferguson's Cafeteria in the Mountain Inn on Center Street. The Blue Mill continued in operation for a half century, closing in 1968. (Photograph by *Northwest Arkansas Times*; courtesy Shiloh Museum/WCHS Collection, P-2469.)

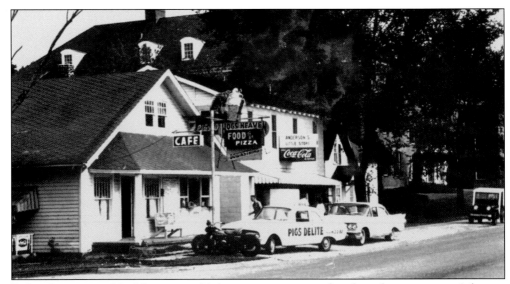

Before the mascot of the University of Arkansas was a protected trademark, stores across Arkansas traded on the Razorback brand, including the Hogs Heaven Café and Pigs Delite, which were at the southeast corner of Garland Avenue and Douglas Street. Next door was Anderson's Little Shop, a small grocery. The cafés and grocery catered to university students who lived in nearby Holcombe Hall, Davis Hall, and the sorority houses. The buildings, pictured in the early 1960s, were removed for the construction of Futrall Hall in 1963. A small University of Arkansas parking lot now covers the site. (Courtesy Shiloh Museum/WCHS Collection, P-4257.)

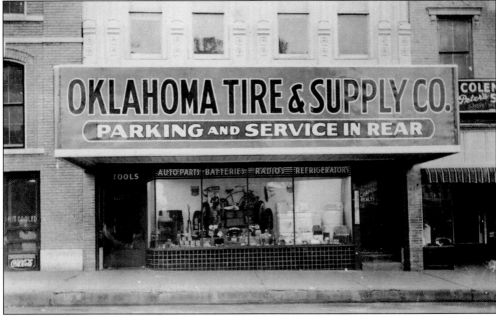

The Oklahoma Tire and Supply Company, better known by its abbreviation, OTASCO, began operating on the east side of the square in the late 1950s and continued at that site until 1970. Like many merchants at that time, OTASCO moved its operations off the Fayetteville square, locating at 524 South School Ave., where it operated until 1987. It is pictured in a photograph most likely taken in the 1940s. (Courtesy Shiloh Museum/WCHS Collection, P-468.)

Five

PARADES AND PERFORMERS

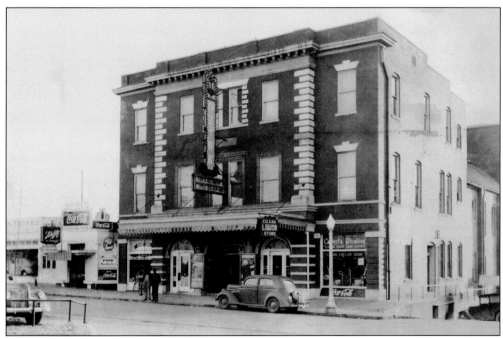

Built in 1905 as the Knights of Pythias Opera House, the theater was soon renamed the Ozark Theater, shown around 1940. Over the course of the next 70 years, it offered silent movies, vaudeville performers, political rallies, Chautauqua lecturers, and a marathon showing of the *Planet of the Apes* movies. It screened its last movie in the summer of 1976. The building languished during the next 20 years, and its back portion, which housed the auditorium and stage, fell into disrepair. This section was removed, and the rest of the building was remodeled into office space in the early 2000s. (Courtesy Shiloh Museum/WCHS Collection, P-43.)

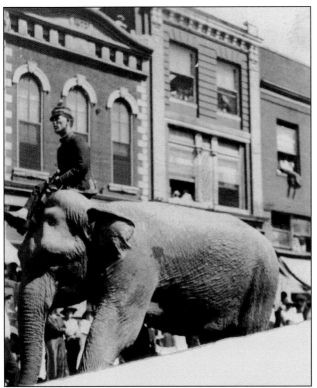

A parade of the Barnum and Bailey Circus crosses the square on Center Street during the late 1890s on its way to the fairgrounds, then near East Maple Street and Mission. The first known circus to visit Fayetteville was Mabie Brother's Circus in 1859. P.T. Barnum's circus first came to Fayetteville in 1888, one of many that visited during the latter years of the 19th century, when the railroad made travel to the region easier. S.H. Barrett's Monster Shows visited in 1887, and French's Railroad Shows, Hippodrome, and Menagerie came in 1889. (Courtesy Shiloh Museum/ WCHS Collection, P-134.)

On September 28, 1898, William F. Cody brought Buffalo Bill's Wild West Show to Fayetteville during a swing through Arkansas. The riding, roping, and wrangling of the cowboys and Indians were carried out at the fairgrounds on eastern Maple Street. While in town, Cody visited with Capt. Charles Ludwig Von Berg, a fellow scout during the 1870s, who bore a strong resemblance to Cody, especially when he wore his frontier garb. (Courtesy Shiloh Museum/WCHS Collection, P-244.)

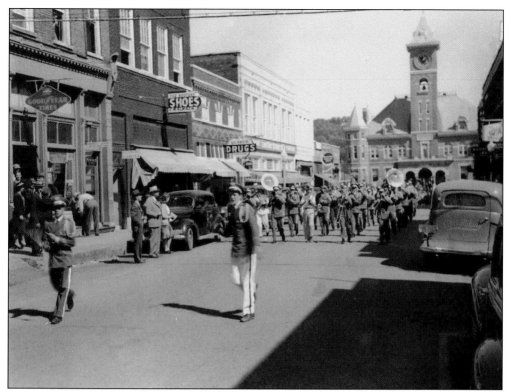

A drum major, moving a little too quickly for the photographer, leads a band up Center Street during the 1940s. (Courtesy UA Libraries/WSC Collection, MC1427.)

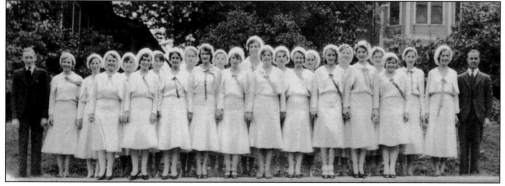

The Fayetteville Glee Club poses for a group portrait in the 1930s. The instructor was Professor Fouts, and the business manager was John Kane. (Courtesy UA Libraries/WSC Collection, MC1427.)

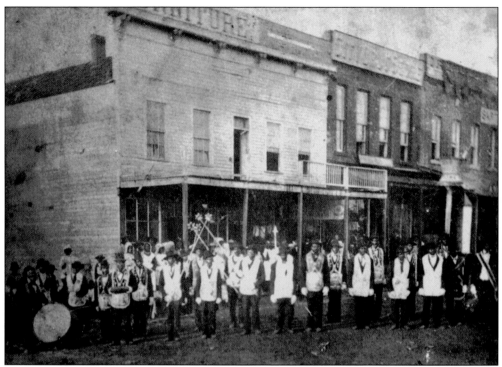

A band and members of a fraternal organization, possibly the African American chapter of the Masonic Lodge or the Knights of Pythias, pose for this c. 1910 photograph in front of Thomas D. Boles's large store, the Fayetteville Furniture Exchange. (Courtesy UA Libraries/McIlroy Bank Collection, MC890.)

Among the many acts performed at the Ozark Theater was this Tom Thumb wedding, sometime around 1914, in which young students played the many parts of a wedding entourage. Among the participants are Alberta McAdams as the bride and Chris Williams as the groom. Other students include Scott Hamilton, Andrew Hamilton, Joe Cannon, Vaughn Moore, Charley Moore, Gordon Gulley, Norman McCartney, Bates Reed, Arthur Eason, Preston Hall, Alice Hight, Headley Harris, Jeff Williams, Ruth Trent, Margaret Stuckey, Allie Simco, Ruth McCartney, Julia McAdams, Elizabeth Crockett, and Frances Wilson. (Courtesy Shiloh Museum/WCHS Collection, P-54.)

Cast members strike a pose in front of the Ozark Theater in October 1930. The cast was putting on a show sponsored by the Business and Professional Women's Club. Although the Ozark brought in many traveling shows, it also provided space for community theater. (Courtesy Shiloh Museum/WCHS Collection, P-176.)

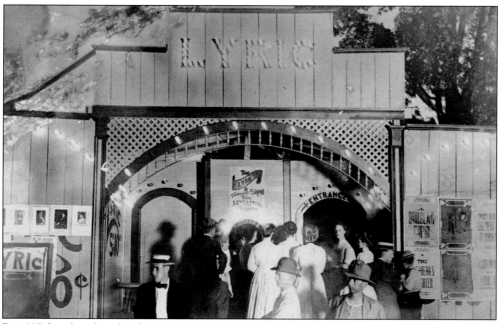

By 1907, barely a decade after Louis Lumiere had refined his motion picture camera and Thomas Edison had invented a way to project film, Fayetteville audiences could watch the moving pictures. And by 1911, Frank Barr had opened the Lyric Movie House, pictured in the 1910s, at the corner of Meadow Street and Block Avenue to show silent pictures. (Courtesy Shiloh Museum/WCHS Collection, P-4129.)

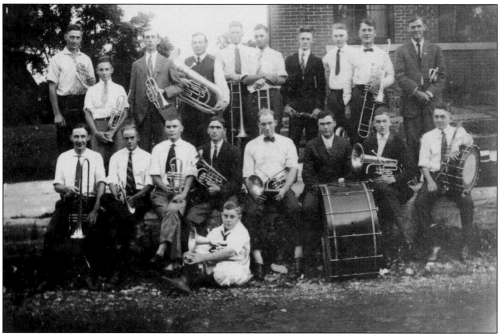

When the Airdrome Theatre opened in 1913 as an open-air movie theater, an orchestra was organized to accompany the silent film. In 1915, the Airdrome Theatre Orchestra included, from left to right, (on the ground) James Chapman; (first row, seated) Owen Mitchell, Charles Skillern, Edgar Wright, Roy Scott, Millard Jernigan, Boomer Ladd, Dave Hansard, and Mack Hulse; (second row, standing) Bruce Rollins, Coo Brown, Lester Fritz, Walter Lemaster, Floyd Broyles, Lyle Bryan, C. Smith, John Skillern, Ned DeWitt, and Bill Summers. (Courtesy Shiloh Museum/WCHS Collection, P-190.)

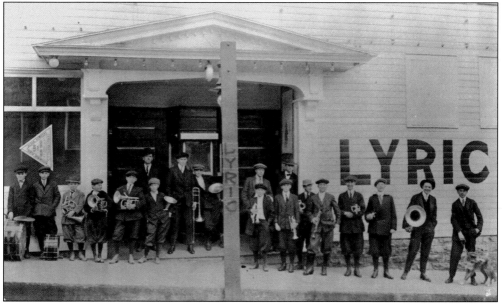

Not to be outdone, Frank Barr (center) organized Barr's Boys Band to play at the Lyric Theater, which stood at 101 North Block Ave. in mid-1910s, when this photograph was made. Also identified is Wade King Hudgins (second from left). (Courtesy Shiloh Museum/WCHS Collection, P-1211.)

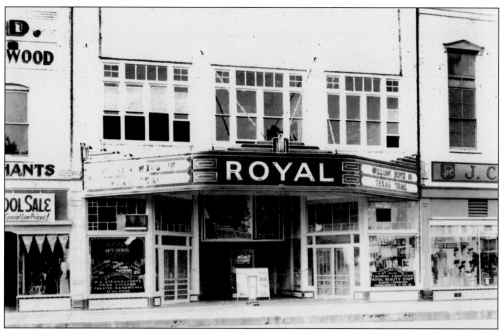

E.A. Budd owned half the south side of the square by the 1920s, including Budd's Royal Theatre, which opened in 1921. The theater, pictured about 1939, presented movies and booked vaudeville performers. Today, the building houses Tiny Tim's Pizza and the West Mountain Brewery on the first floor and offices upstairs. (Courtesy Shiloh Museum/WCHS Collection, P-338.)

In the 1910s, a troupe of actors stands on Block Street near its intersection with Mountain Street. In the background is the Washington Hotel, where many actors with traveling shows stayed because of its proximity to the theaters. (Courtesy Shiloh Museum/WCHS Collection, P-4145.)

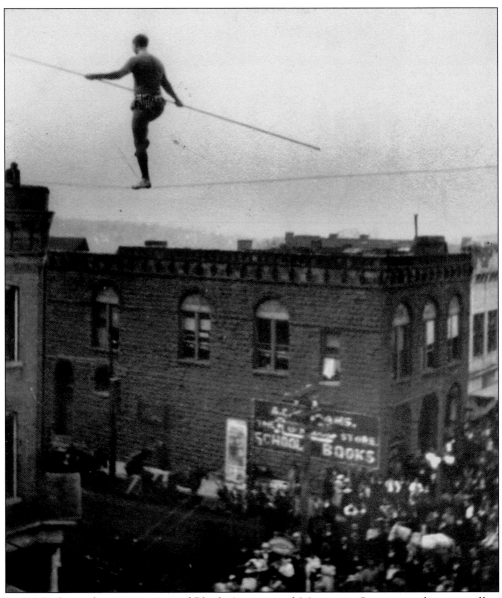

In 1925, above the intersection of Block Avenue and Mountain Street, a tightrope walker performed on a high wire. He crossed between Budd's Store, out of sight to the right, and the Washington Hotel, the entrance of which can be seen at the left. (Courtesy UA Libraries/WSC Collection, MC1427.)

Joy Pratt Markham began a summer camp on her family land atop Markham Hill. Named Hilltop Camp, it taught a variety of outdoor skills, including horseback riding, camp cooking, and astronomy, as well as arts and crafts. This photograph is from the 1920s or 1930s. Today, the grounds are part of the Pratt Place Inn. (Courtesy Shiloh Museum/WCHS Collection, P-280.)

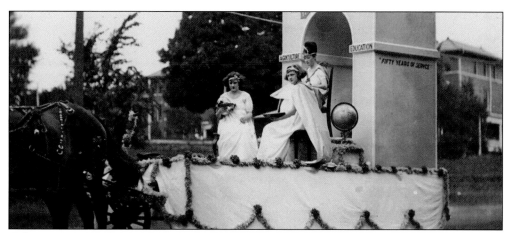

A float promoting the university's first 50 years of teaching agriculture and education (1872–1922) passes by the campus on Arkansas Avenue with Carnall Hall barely visible in the background. (Photograph by the Sowder Studio; courtesy UA Libraries/WSC Collection, MC1427.)

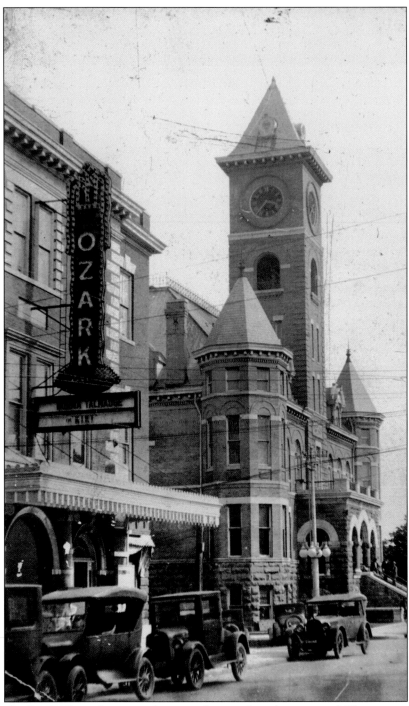

Between the Ozark Theater's stream of movies, theatrical productions, and Chautauqua speakers and the 1905 Washington County Courthouse's steady flow of criminal trials and political announcements, the intersection of College Avenue and Center Street proved to be a popular and heavily trafficked location in 1926. Construction of the courthouse was finished in 1905, and the Ozark Theater was built the next year. (Courtesy UA Libraries/WSC Collection, MC1427.)

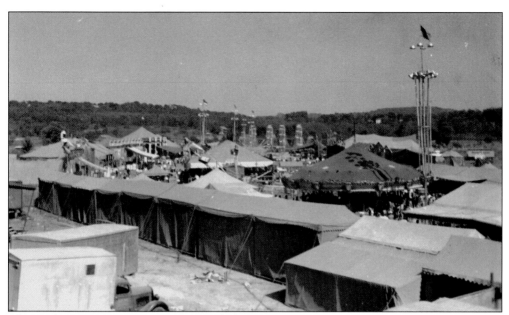

The Washington County Fair in 1939 included many of the same elements as the first county fair in 1856—livestock, races, and exhibitors. The fair ceased in 1859 and wasn't revived successfully until 1906. The fairgrounds were at the northwest corner of present-day Razorback Road and Martin Luther King Boulevard, the site of these two photographs (showing the midway, above, and an exhibitor with two Hereford yearlings, below). The fairgrounds were moved to their present location on the western edge of the University of Arkansas Agricultural Experiment Farm in the 1960s. (Both courtesy Shiloh Museum/WCHS Collection: above, P-282-1; below, P-282-2.)

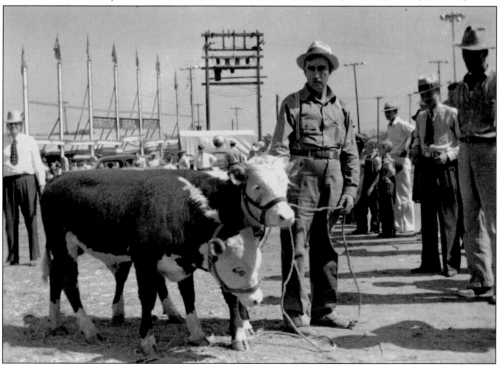

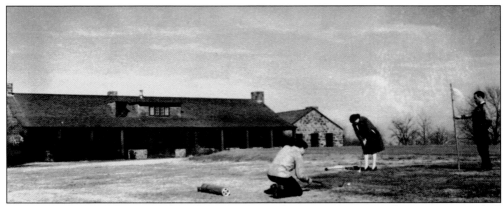

Hiram Brandon (left) lines up a shot while Blanche Hight prepares to putt and Errington Campbell holds a flag at the golf course of the Fayetteville Country Club around 1940. The club was organized about 1923 and had around 60 members initially. In 1926, the organization bought the 182-acre Crozier farm on the southern end of South Mountain and erected the stone clubhouse seen in the background. John Francis, a golf expert from Tulsa, supervised layout of the 18-hole golf course. (Courtesy UA Libraries/WSC Collection MC1427.)

The Men's Gymnasium at the University of Arkansas frequently hosted national performers at its Community Concerts Series during the 1950s: musical performers such as Louis Armstrong and Count Basie, speakers such as Frank Lloyd Wright, and actors such as Charles Boyer and Agnes Moorehead. Built in 1938 and originally named the Fieldhouse, the building is shown in its first year during the Washington County Public Schools' Music Festival. The building later served as the university museum and is now the university's Center for Space and Planetary Science. (Courtesy Shiloh Museum/WCHS Collection, P-1067.)

Six

RELIGIOUS LIFE

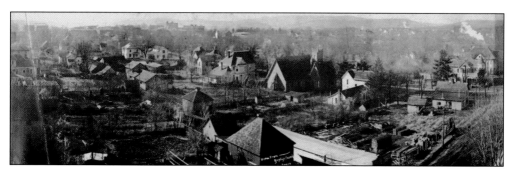

St. Paul's Episcopal Church on East Avenue sits at the center of this 1908 vista of Fayetteville. The congregation was organized in 1848 and built this church, dedicating it in April 1888. Although it continues to be used by the Episcopal Church, the many houses surrounding it have slowly disappeared, becoming business offices and commercial buildings. (Photograph by Burch Grabill; courtesy Shiloh Museum/WCHS Collection, P-3827A.)

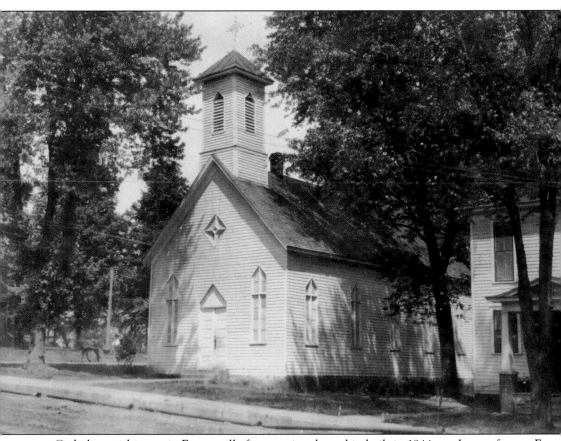

Catholic parishioners in Fayetteville first met in a log cabin built in 1844 northeast of town. Fr. John Gary conducted the early services. In June 1878, a new clapboard chapel, pictured in the early 20th century, was dedicated at the corner of Lafayette Street and Willow Avenue, where the Catholic Church slowly grew, starting a parochial school in 1916, rebuilding the chapel with brick in 1936, and adding a larger worship center. Parishioners moved to a new church and school on North Starr Drive in 2002. (Courtesy Shiloh Museum/WCHS Collection, P-287.)

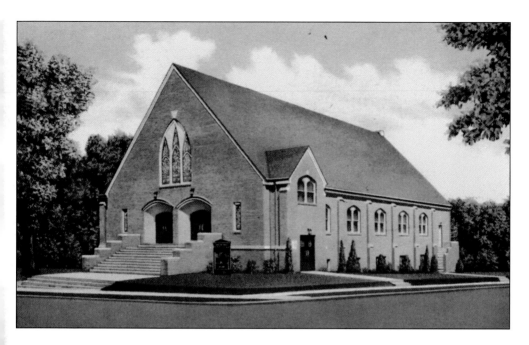

The Church of Christ in Fayetteville was started in 1886 when a group of congregants at the First Christian Church withdrew because they opposed the use of musical instruments in the church. The members initially met in a building on Government Avenue (below), but the congregation outgrew that building in the 1940s and erected the church above at the northwest corner of Center Street and Locust Avenue, dedicating it on September 11, 1948. Now called the Center Street Church of Christ, it has been expanded to allow further growth but continues to operate at the same corner. (Postcard above courtesy Charlie Alison; below courtesy UA Libraries/Historical Records Survey, MS H62.)

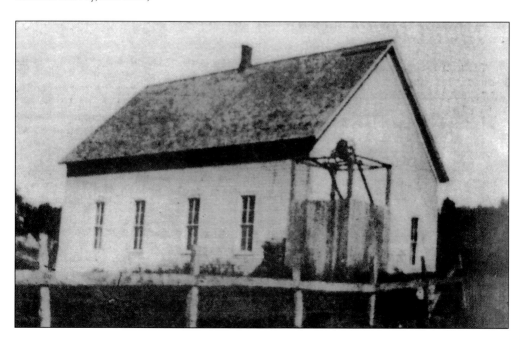

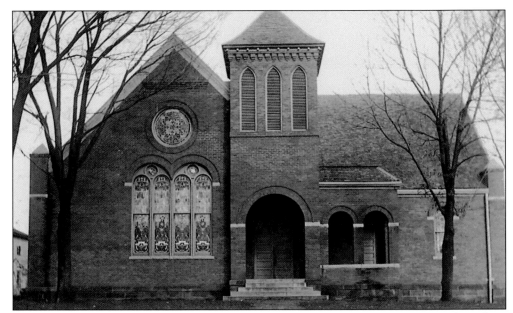

The First Christian Church, pictured around 1895, was built in 1872 at 220 North College Ave. on the site of Arkansas College, which had burned during the Civil War. The Fayetteville congregation built its first church at the southwest corner of the square, but it had burned during the war, as well. In 1900, an annex was added to the left side of the building. In the early morning hours of December 12, 1912, the furnace of the church apparently set the building afire and it was destroyed. The congregation built a new sanctuary that is still in use today. (Both photographs courtesy First Christian Church.)

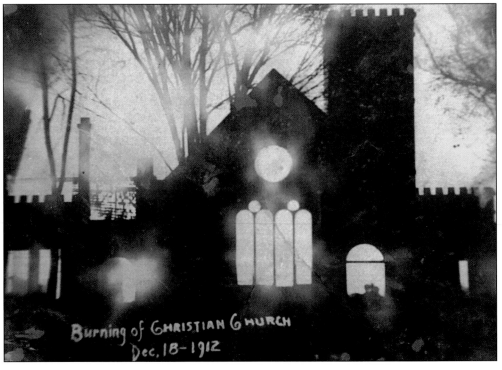

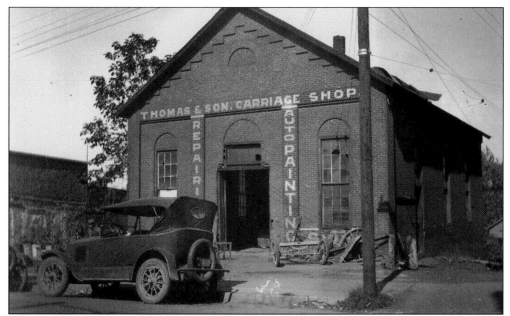

The Methodist congregation first met in this church, which was built at 112 West Center St. in the early 1870s. By 1929, when this photograph was made, W.A. Thomas and Ben Thomas had opened the Thomas and Son Carriage Shop. The Thomases worked on carriages and wagons in the last days of horse-drawn vehicles and then shifted their blacksmith expertise to horseless carriages. The building was razed in the mid-1970s to make way for a parking lot. (Photograph by Peggy Lighton; courtesy Shiloh Museum/WCHS Collection, P-2677.)

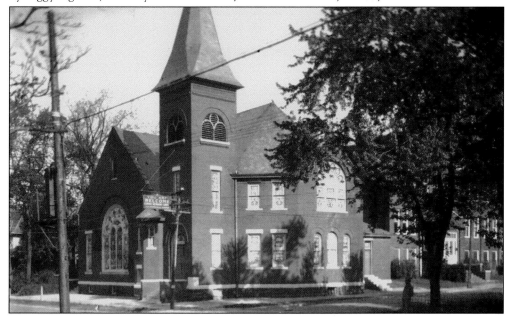

After the Methodist congregation outgrew their first church, members constructed a new building in 1899 on the northwest corner of Highland Avenue and Dickson Street (pictured in 1927). The church's sanctuary was torn down after a new one was built next door, although the rear portion, barely seen through the trees, was retained and is still standing. (Courtesy Shiloh Museum/WCHS Collection, P-301.)

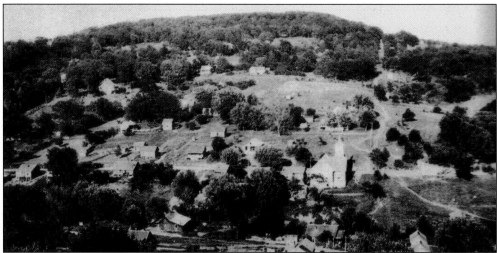

The St. James African Methodist Episcopal Church, pictured about 1928, was completed in 1884 at the northwest corner of Willow Avenue and Center Street. The congregation began meeting together about 1861, prior to emancipation. The church, now called St. James United Methodist Church, is still standing. (Courtesy Charlie Alison.)

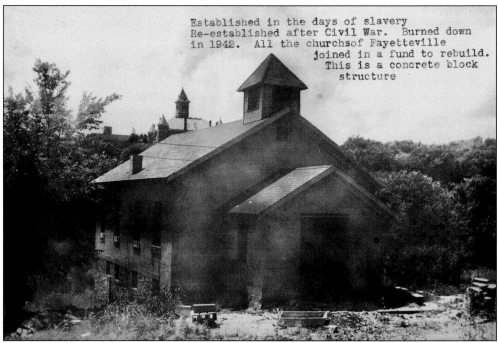

When St. James Baptist Church burned in 1942, congregations from across town pitched in to help build a new church, seen here near its completion. Organization of St. James Baptist Church began prior to the Civil War when slaves began worshiping together. After emancipation and the end of the Civil War, they built a church at the southwest corner of Mountain Street and Willow Avenue. The 1942 building was eventually replaced by a larger building. The congregation outgrew even that space, moving across town to the northeast corner of North Street and Leverett Avenue in 2007, to the church built by the North Street Church of Christ. (Courtesy UA Libraries/WSC Collection, MC1427.)

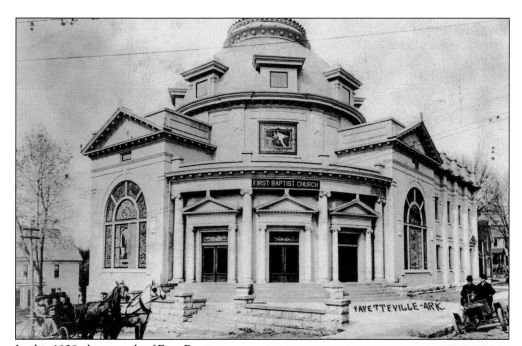

In this 1908 photograph of First Baptist Church, located at the northwest corner of College Avenue and Dickson Street, the old and the new come together—a horse-drawn carriage to the left and a tin lizzie to the right. First Baptist Church continues to hold its services on the site, although structural problems with the dome forced the congregation to replace this building with the current sanctuary, dedicated February 14, 1960. (Courtesy Charlie Alison.)

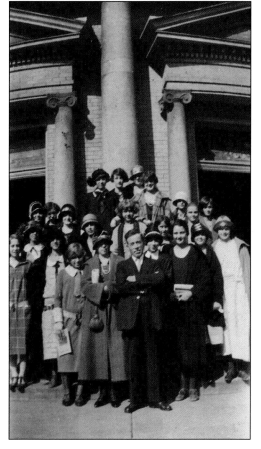

William Simeon Campbell and a bevy of Baptist women stand in front of the First Baptist Church, just outside its entrance at the corner of College Avenue and Dickson Street. (Courtesy UA Libraries/WSC Collection, MC1427.)

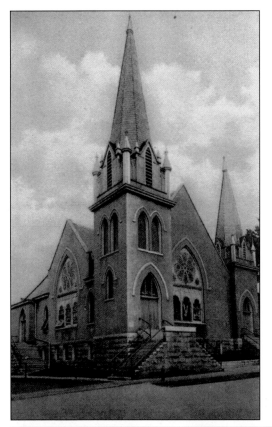

This postcard is of the First Presbyterian Church (left, in the early 20th century), which was built in 1904 on the northwest corner of College Avenue and Spring Street, the site of the previous Presbyterian church, which had been built in 1877 and was moved to south Fayetteville. Meanwhile, Cumberland Presbyterians built the Central Presbyterian Church (below, in the 1920s) at the northeast corner of Dickson Street and St. Charles Avenue in 1906. Congregations of the two churches joined together in 1953 and built a new church on Knox Drive in 1961. Both earlier buildings were torn down, the former made way for an office building and the latter for a new post office. (Both courtesy Shiloh Museum/WCHS Collection, P-288 below and P-290 left.)

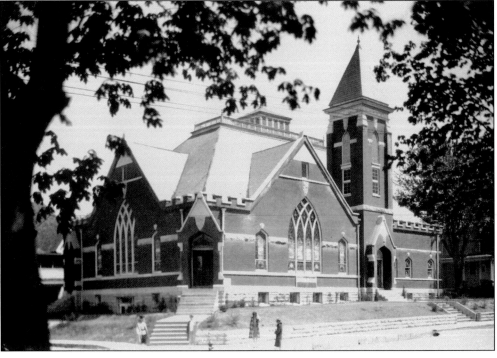

Seven

A CROSSROADS OF
TRANSPORTATION

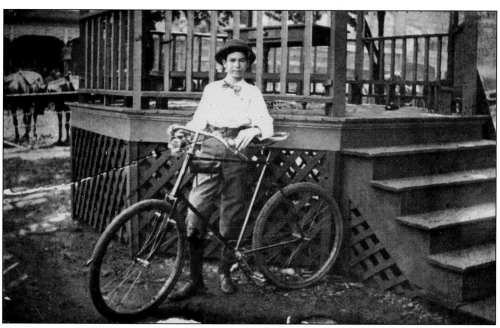

Roy Nix, dressed in the latest fashion for bicyclists—knickers and a bowtie—stands next to his new safety bicycle, with the north side of the square in the background. Nix was born in 1879. The bicycle and lantern are similar to those produced in the 1890s, suggesting a date for the photograph. Nix later worked as a salesman for the Leader Company, purveyors of clothing and furnishings, on the east side of the square. Today, the city has more than 18 miles of paved recreational paths, with another 100 miles of future trails identified. (Courtesy Shiloh Museum/ WCHS Collection, P-1210.)

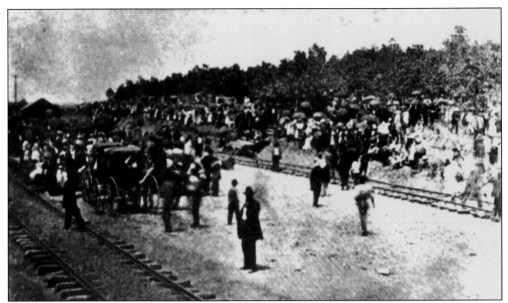

A crowd, estimated by newspapers to include 10,000 people, greeted the first train into Fayetteville with speeches, toasts, and applause. C.M.N. Rogers, vice president of the St. Louis and San Francisco Railway, arrived on the train on June 8, 1881, riding in a passenger coach named "Fayetteville." He and other railway officials met crowds near where present-day North Street crosses the track. The first regularly scheduled passenger train ran south from Fayetteville to Van Buren on July 4, 1882. (Above, courtesy Shiloh Museum/WCHS Collection, P-1398B.)

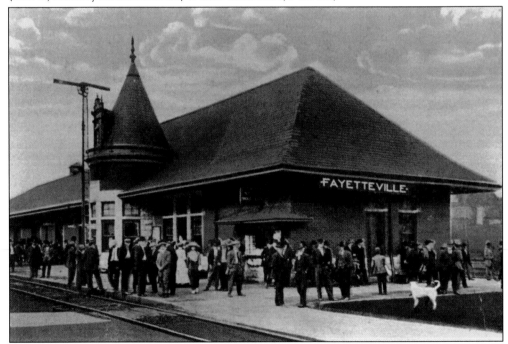

After the railroad's first depot burned down, a brick building with a round dispatcher's office was built on Dickson Street, seen in this c. 1915 postcard. This building was replaced in 1925 with the current southwestern-style depot. (Courtesy Gresham; UA Libraries/Kent Brown Collection, M475.)

The platform of the Fayetteville Depot proved to be a popular place during the 1940s and 1950s. University of Arkansas students (above) wait to board a passenger train of the St. Louis and San Francisco Railway in the late 1940s. The flow of trains made the depot one of the social hot spots in Fayetteville during the early part of the 20th century. (Courtesy Shiloh Museum/WCHS Collection, P-740.)

This postcard shows U.S. Highway 71 on the north side of Fayetteville, looking south toward Fayetteville and the valley of Mud Creek. Today the highway is six lanes wide, and Joyce Boulevard crosses near the bottom of the hill. (Courtesy Charlie Alison.)

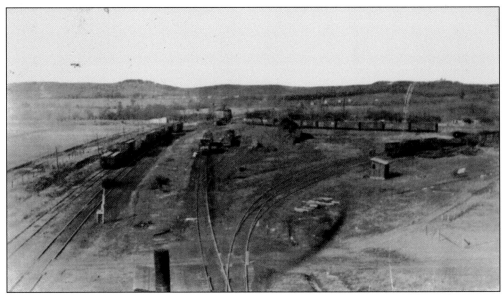

The Fayetteville and Little Rock Railroad, which ran eastward up the valley of the White River, joined the main line at Fayette Junction, pictured in 1908. The junction is near the present-day intersection of Cato Springs and Razorback Roads, south of the University of Arkansas Baum Stadium. Most of the line, which became known as the St. Paul Branch, was abandoned in 1937. (Courtesy Charlie Alison.)

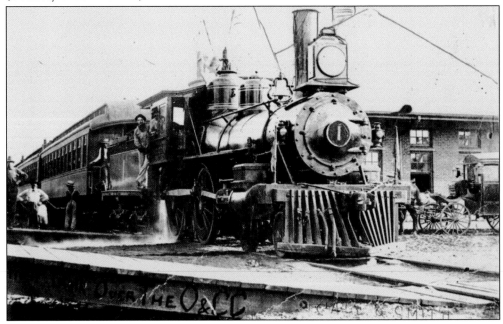

The Ozark and Cherokee Central Railroad was established in 1901, eventually connecting Fayetteville with Muskogee, Oklahoma. The first train on the line is pictured, starting out August 22, 1901. The line left town along the present-day path of the Frisco Trail, passed the Ozark and Cherokee Central Depot, which stood about where the Food Co-op is now, and then turned west, paralleling present-day Martin Luther King Boulevard. The Ozark and Cherokee Central ceased operations in 1942. (Courtesy Shiloh Museum/WCHS Collection, P-1393.)

These c. 1907 photographs show what are believed to be Fayetteville's first automobiles. Harry Baum, Dr. Otey Miller, and Dr. Charles Richardson were the first owners. The Mulholland House, at the southeast corner of Washington Avenue and Lafayette Street, is pictured above. Richardson (below) is in what appears to be a Ford. (Both courtesy Shiloh Museum/WCHS Collection: above, P-249; below, P-259.)

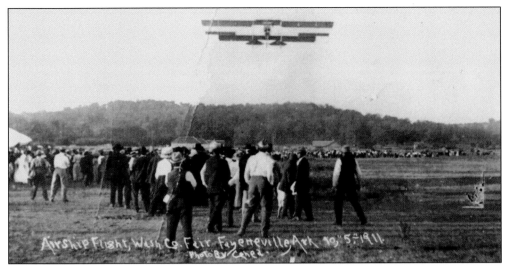

Fayetteville's first air flight occurred on October 5, 1911. The plane was designed by Glenn H. Curtiss, an early aviation pioneer, and piloted by Glenn L. Martin, who founded Martin Aviation Company in Santa Ana, California, the next year. Martin gained an elevation of 1,800 feet, according to local newspapers. He flew south from the 1906 Washington County Fairgrounds, circled back over the grandstand, headed northeast across the southern part of Fayetteville, and returned to land at the fairgrounds without incident. (Photograph by Cohea; courtesy Shiloh Museum/WCHS Collection, P-236.)

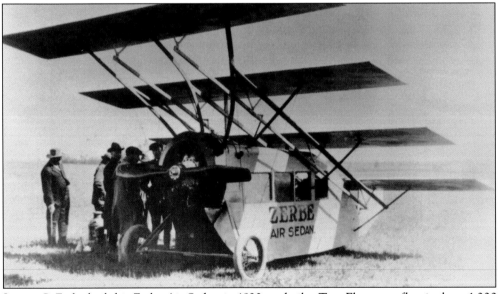

Jerome S. Zerbe built his Zerbe Air Sedan in 1920, and pilot Tom Flannerty flew it about 1,000 feet at the Washington County Fairgrounds, gaining as much as 40 to 50 feet of altitude before landing. Zerbe had experimented with aircraft design as early as 1908, building a six-plane aircraft in Los Angeles. In 1910, he followed it up with a five-plane twin-prop craft that was built for the Dominguez Air Meet in Los Angeles. Neither aircraft is known to have successfully left the ground. Zerbe moved to Fayetteville in 1920 and undertook design and construction of a passenger plane on behalf of several Missouri businessmen. (Courtesy Shiloh Museum/WCHS Collection, P-165.)

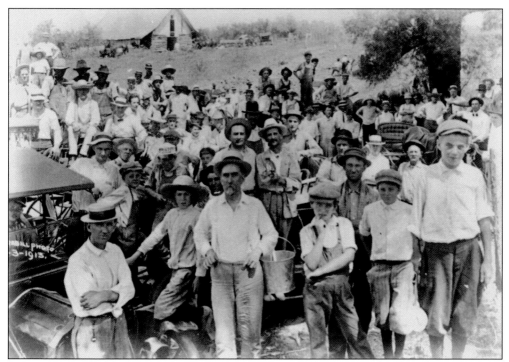

During the early part of the 20th century, when roads needed work, county residents were expected to help. The road crew photographed by Burch Grabill in September 1918 included Jerome Reynolds, Bill Lewis, Art Lewis, Hugh Reagan, Bose Williams, Charles Winkleman, Bruce Holcomb, Zenas Lytton Reagan, John Tillman, Bill Yates, E.E. Mashburn, J.J. Baggett, John Snyder, E.C. Pritchard, and Earl Ellis. (Photograph by Burch Grabill; courtesy Shiloh Museum/ WCHS Collection, P-186.)

Fayetteville's streets remained dirt until the 1920s, when paving with macadam or concrete began to take place. Here, Ila Street, looking west toward its intersection with Wilson Avenue, is being prepared for paving. (Courtesy Shiloh Museum/WCHS Collection, P-2800.)

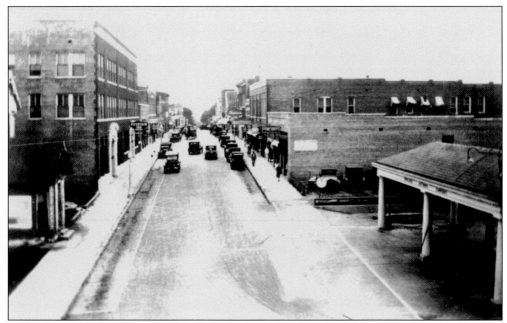

By the early 1930s, when this photograph was taken, automobiles dominated Center Street, pictured from the front balcony of the 1905 Washington County Courthouse. However, an occasional covered horse-drawn carriage could still be seen downtown, as is evidenced far down the street. (Courtesy Shiloh Museum/WCHS Collection, P-466B.)

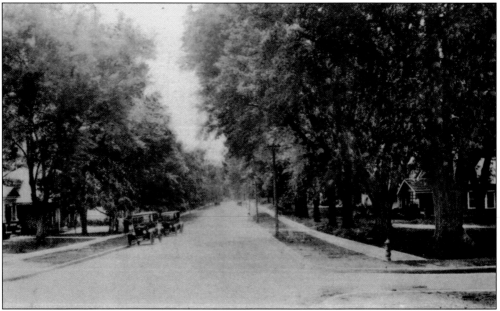

Looking west on East Lafayette Street at its intersection with Olive Avenue about 1928, this scene is very similar to today's view. The houses in the picture are still standing, but the vehicles look less like Model Ts and can't park on the street. (Courtesy Charlie Alison.)

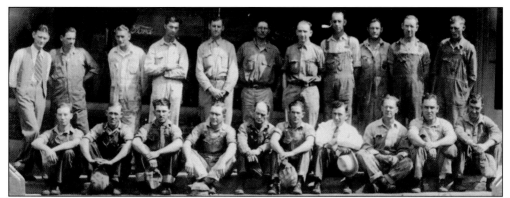

Members of the Service Courtesy Club of Filling Station Operators and Attendants pose for a photograph outside the Ford dealership in this c. 1935 photograph. The group was sponsored by the chamber of commerce, under the leadership of secretary Scott D. Hamilton. (Courtesy UA Libraries/WSC Collection, MC1427.)

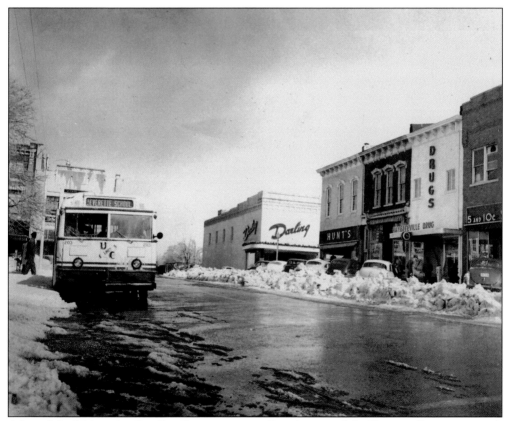

A bus of the University-City Bus Service stops on East Avenue of the Fayetteville square to pick up passengers after a snowstorm in the early 1950s. Like the other sides of the square, the east side contained primarily retail shops fronting the street with offices upstairs. Today, Razorback Transit, operated by the University of Arkansas, provides free transportation from the square to campus and the Northwest Arkansas Mall. (Courtesy UA Libraries/WSC Collection, MC1427.)

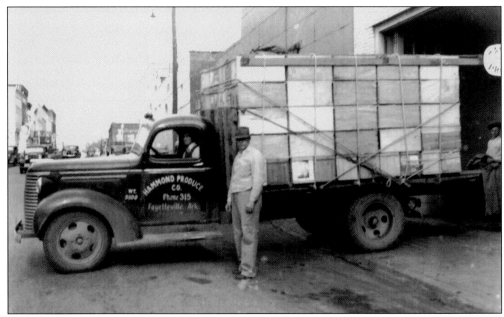

Delivery trucks became a common sight on the streets of Fayetteville from the 1920s onward. Ira Hammond of Elkins (standing) operated Hammond Produce from about 1935 into the early 1940s, initially on the east side of the Fayetteville square. He moved his operation to 20 East Mountain St. by 1939. (Photograph by *Northwest Arkansas Times*; courtesy Shiloh Museum/ WCHS Collection, P-2493.)

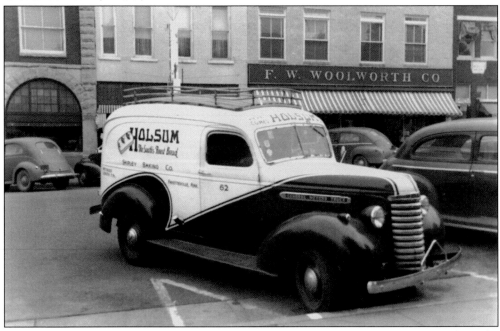

A Holsum Bread delivery truck, owned by the Shipley Baking Company, is pictured on the square in May 1943. Buildings on the north side of the square, in the background, include the First National Bank at left and the F.W. Woolworth Company at right. (Photograph by *Northwest Arkansas Times*; courtesy Shiloh Museum/WCHS Collection, P-2643.)

Eight

PUBLIC SERVICE
AND GOVERNMENT

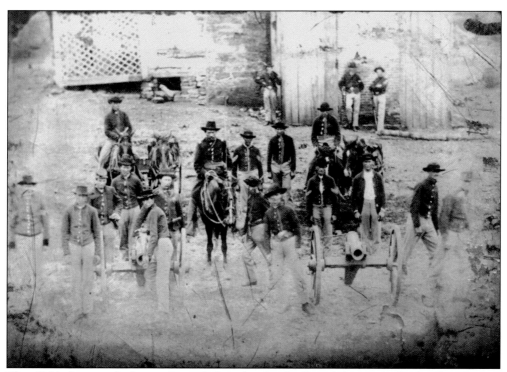

This 1864 photograph shows what is believed to be the First Arkansas Light Artillery Battery (Union) while it was posted in Fayetteville to enforce martial law during the latter part of the Civil War. The Light Artillery Battery was organized at Fayetteville in early 1863 under the supervision of Union colonel Marcus LaRue Harrison. The officer on horseback between the cannons is reputedly Denton Stark. (Courtesy Shiloh Museum/WCHS Collection, P-1534.)

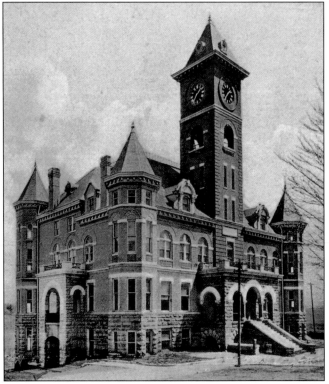

The slouch hats, velvet vests, and canvas dusters of the 1880s (above) are those of cowboys standing outside the Washington County Courthouse. It was built in 1870 at the center of the Fayetteville square, replacing the previous courthouse, which had burned during the Civil War. Along with county offices, the courthouse held Fayetteville's municipal offices. It was razed about 1908, after construction of the fifth courthouse (left), located at the intersection of Center Street and College Avenue. This courthouse, now known as the Historic Washington County Courthouse, was designed by Charles Thompson and dedicated to service in 1905. It was renovated by the county and rededicated in 2010. (Both courtesy UA Libraries/McIlroy Bank Collection, MC890.)

Built at the intersection of Mountain Street and College Avenue in 1897, the Washington County Jail, pictured around 1910, provided office space for the county sheriff as well as more secure jail cells that were capable of accommodating 14 inmates. It served until the 1970s, when a new jail was built a little over a block north. The Washington County Historical Society helped restore the building in the 1970s, and it continues to be used as private offices today. (Courtesy Charlie Alison.)

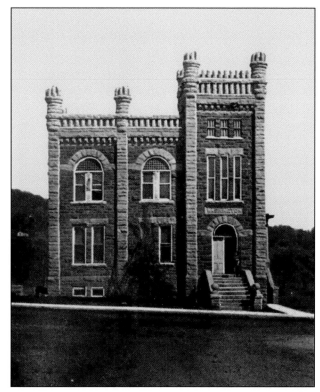

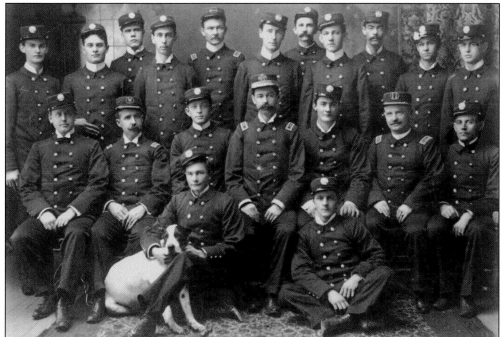

These Fayetteville firefighters posed for a photograph in 1893. Among the men are (standing) Dick Putman (second from left), Claude Nix (fourth from left), and Con(?) Nix (sixth from left). Jim Bozarth is holding the firehouse dog, Old Poley. (Courtesy Shiloh Museum/WCHS Collection, P-2364.)

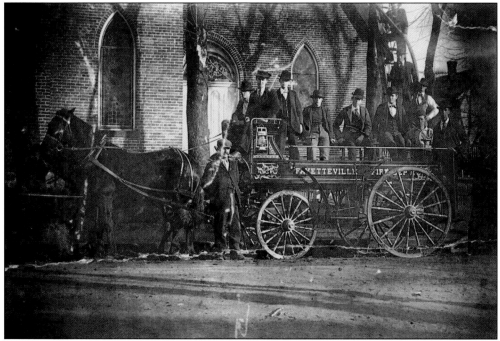

Fayetteville's first fire wagon and its crew pose in this c. 1900 photograph in front of St. Paul's Episcopal Church on East Avenue (above). The city bought the wagon in 1897 and kept it in a long shed on the east side of Block Avenue, just north of Meadow Street. In 1917, the city purchased a motorized American LaFrance fire engine. In this c. 1920s photograph, it is coming out of the city's original fire station on Block Avenue, with firefighters aboard. (Above, courtesy Charlie Alison; below, photograph by Hugh Sowder; courtesy Shiloh Museum/WCHS Collection, P-242.)

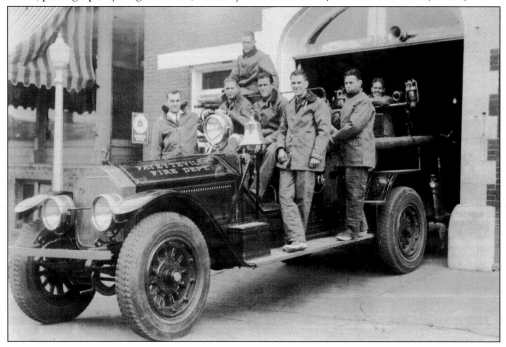

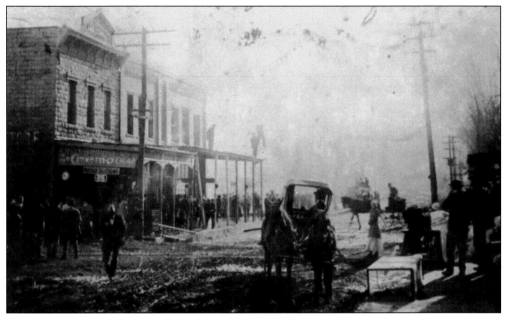

A fire in the early morning hours of March 27, 1911, consumed several buildings in the middle of the 400 block of West Dickson Street. The fire apparently started at Hodges Café and spread to Ladd's Barber Shop, McAdams' Drug Store, and J.W. Lisko's Barbershop. The fire proved an early test of the city's new water line from Clear Creek. Initially, the pressure was low, but word was sent to turn the pump on, and pressure was soon restored. Firefighters used dynamite to knock the City Bakery building into Dickson Street to keep the fire from spreading. (Courtesy Shiloh Museum/WCHS Collection, P-241.)

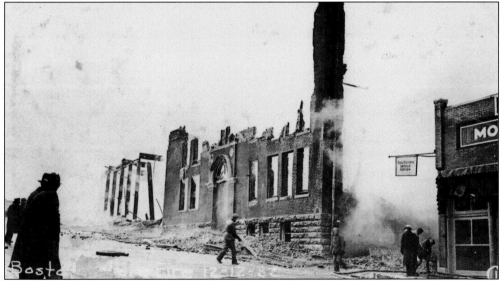

One of the worst fires in the city's downtown occurred on December 12, 1932, when the Boston Store caught fire on the square and spread west to the upstairs of the Red Cross Drug Store. Five firefighters were injured keeping the fire from spreading to McIlroy Bank and buildings across East Avenue. Boston Store rebuilt on the site and remained at the location for another 40 years. (Courtesy Shiloh Museum/WCHS Collection, P276-F.)

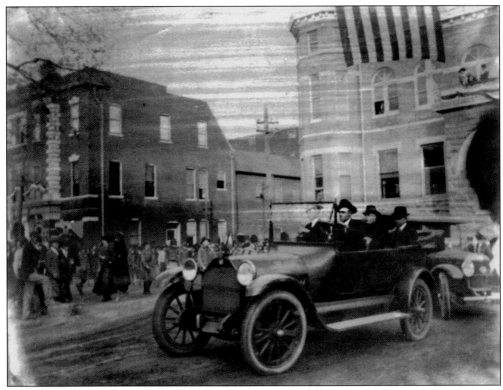

Former president William H. Taft rides in the back seat of a car turning onto Center Street in front of the 1905 Washington County Courthouse. Taft made speeches at the Washington County Courthouse and to students at the University of Arkansas during his stop in Fayetteville in 1917. At least five other men—Herbert Hoover, Richard Nixon, Jimmy Carter, George H.W. Bush, and Bill Clinton—have visited Fayetteville either prior to, during, or after their presidencies. (Courtesy Shiloh Museum/WCHS Collection, P-4369.)

Pres. Grover Cleveland appointed Hugh Anderson Dinsmore of Fayetteville as the nation's first consul general to the Kingdom of Korea. He held this post from 1887 to 1890. Dinsmore served in Congress from 1893 to 1905, and served as a regent of the Smithsonian Institute. He also served several years on the University of Arkansas Board of Trustees. (Courtesy UA Libraries/Hugh Dinsmore Papers, MC1177.)

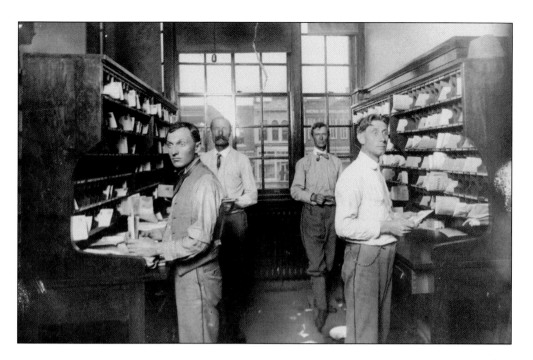

Unidentified postal workers sort mail in front of one of the southern windows of the post office on the square during the 1910s. Fayetteville's first postmaster, Larkin Newton, was appointed in 1828. During the 19th century, the location of the post office shifted from building to building around the square as new postmasters were appointed. In 1911, this permanent post office was built at the center of the square. In the 1960s, a new post office was built on Dickson Street, and the old post office became a restaurant called the Old Post Office Gathering Place. (Above, courtesy Shiloh Museum/WCHS Collection, P-3859; below, courtesy Charlie Alison.)

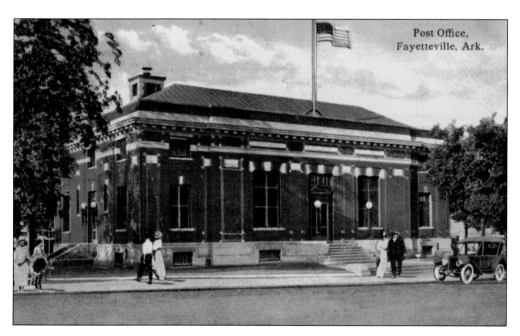

Fayetteville City Hospital, shown sometime between the 1920s and 1950s, was built in 1912 on South School Avenue after a three-year fundraising effort. It had only been open four years when the city built an adjacent training school and home for nurses in 1916. (Courtesy Shiloh Museum/WCHS Collection, P-334.)

Student nurses pose outside Fayetteville City Hospital in 1918, a year that proved to be stressful for all healthcare providers. An influenza epidemic swept the world. Fayetteville had 300 cases and six deaths by October of that year, most of which were on the University of Arkansas campus. The university was put under quarantine during the epidemic, while most public places in town were closed. (Courtesy Shiloh Museum/WCHS Collection, P-29.)

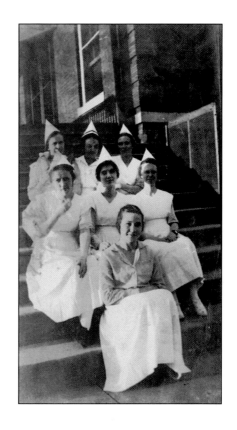

James Cortez Hoover, who served as a private during World War I, returned home after his discharge from the Army and worked until 1954 as an orderly for Fayetteville City Hospital. His wife, Rissie, worked for the hospital as a cook until her death in 1928. Hoover, seen in the early 1920s, was often called to set broken bones at the hospital, and one doctor said that Hoover knew the human bone structure as well as any doctor in the region. In 1920, an annex was added and later named in honor of Hoover. He died December 11, 1954, and is buried at Oak Cemetery. (Courtesy Shiloh Museum/WCHS Collection, P-4428.)

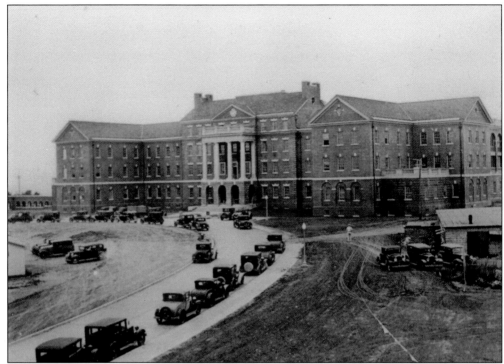

In January 1934, when the Veterans Administration Hospital was nearing completion, Roberta Fulbright, publisher of the *Northwest Arkansas Times*, and Dean William N. Gladson of the University of Arkansas College of Engineering, led a grand march starting the festivities for a fundraiser for the Polio Foundation. Later in the year, the hospital opened for business, and the first patient was admitted on April 2, 1934. More than 160,000 patients were received at the hospital over the next 50 years. (Courtesy the Veterans Affairs Hospital.)

This view of the Veterans Administration Hospital from Highway 71 shows that saplings and rose bushes were among the first bits of landscaping added to the hospital grounds. The trees are mature and many of the roses still bloom today. (Courtesy the Veterans Affairs Hospital.)

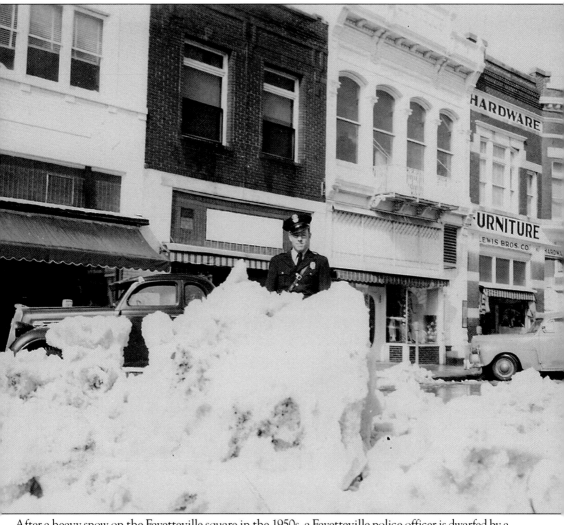

After a heavy snow on the Fayetteville square in the 1950s, a Fayetteville police officer is dwarfed by a pile of snow on the west side of the square. (Courtesy UA Libraries/WSC Collection, MC1427.)

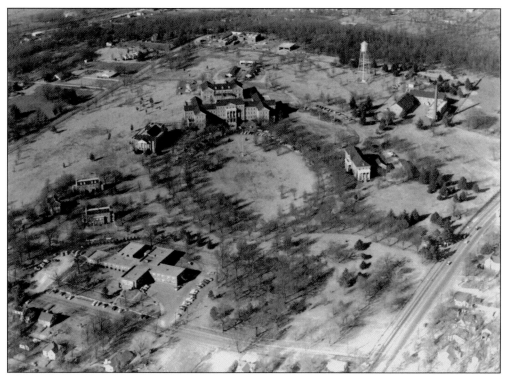

The Veterans Administration Hospital and its elliptical drive are pictured in 1959. Construction of the first buildings of the hospital were started in 1932 on 82 acres spanning the crest of Watermelon Hill, where Hugh Dinsmore Wilson had previously operated a still. College Avenue can be seen at the lower right, and Washington County Hospital, the forerunner of Washington Regional Medical Center, is at the lower left. (Courtesy the Veterans Affairs Hospital.)

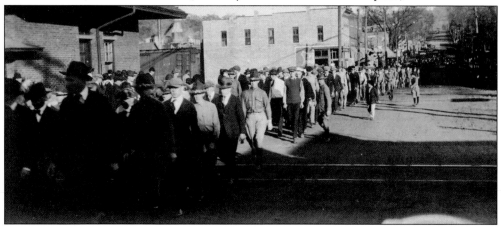

Recruits for the Arkansas National Guard march down Dickson Street on their way to the University of Arkansas to report for training in 1914. The 1st and 2nd regiments were sent to Deming, New Mexico, to patrol the United States border with Mexico. They were back home for barely two months when they were called up for World War I. The building at the immediate left is the old Fayetteville Depot. The building at the center of the image is the Frisco Drug Store, apparently being remodeled on the front corner. Today, the Hog Haus Brewery operates in the same building. (Courtesy UA Libraries/WSC Collection, MC1427.)

Nine
PEOPLE OF FAYETTEVILLE

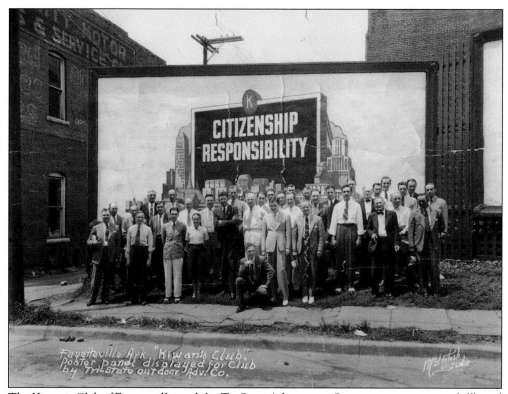

The Kiwanis Club of Fayetteville paid the Tri-State Advertising Company to construct a billboard proclaiming the ideals that its members sought to promote in Fayetteville—"Citizenship, Responsibility: The Price of Liberty." (Photograph by the McIntosh Studio; courtesy UA Libraries/ Charles C. Yarrington Papers, MC949.)

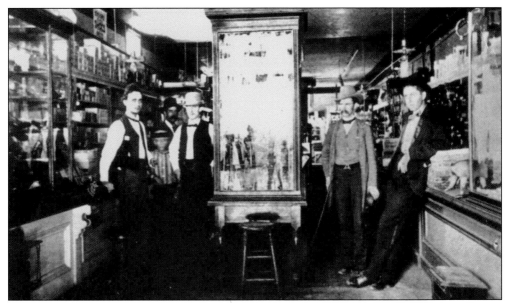

After the Civil War, John A. Reed carried on the mercantile business that his father, George Washington Reed, had started. He partnered with Wallace Ferguson to start a new mercantile, Reed and Ferguson, on the northeast corner of the square, the interior of which is shown. By 1880, they also opened a bank in the rear of their building. In this c. 1890 photograph are, from left to right, John A. Reed, Joe Dickson, Wythe Walker, and Wallace Ferguson. (Courtesy Shiloh Museum/WCHS Collection, P-315.)

James Lafayette "Fay" Reed sits in his surrey sometime in the 1890s. Reed was a traveling salesman who specialized in clothing. He also operated a women's ready-to-wear shop on the square for a period, before returning to the road. He and his wife, Angie, lived at 313 West Fletcher Ave. (Courtesy Shiloh Museum/WCHS Collection, P-480.)

Adeline Blakely is pictured peeling apples on June 11, 1943. Blakely was born into slavery in Tennessee and came to Arkansas with the John P.A. Parks family the next year, moving to Fayetteville when she was five years old. After emancipation, she continued to work as a domestic for descendants of the Parks family and lived with the family at 101 Rock St. in Fayetteville. (Courtesy Shiloh Museum/WCHS Collection, P-1679.)

Edward Durell Stone (left), later a world-renowned architect, stands with three foppish friends outside Buck's Drug Store in 1919. Stone, who was the son and grandson of longtime Fayetteville merchants, attended the University of Arkansas before moving to Boston to attend MIT and Harvard. In addition to his national and international work, Stone designed the University of Arkansas Fine Arts Center, among other buildings in Fayetteville. (Courtesy UA Libraries/WSC Collection, MC1427.)

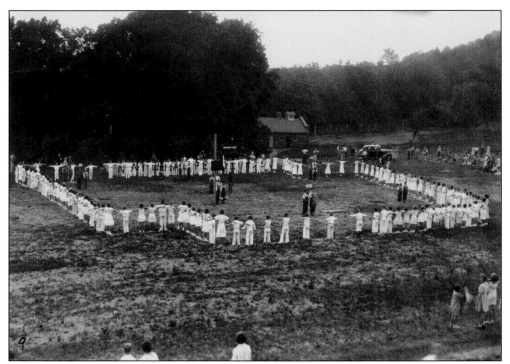

Students present a natural resources pageant at Harmon Playfield in the 1920s or 1930s, lining up in the shape of Arkansas. (Courtesy Shiloh Museum/WCHS Collection, P-479.)

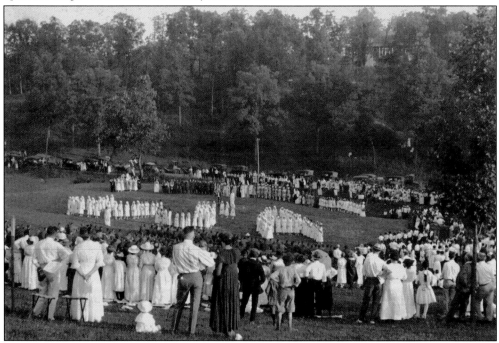

Nursing students spell out USA during a 1919 pageant at Wilson Park celebrating the end of World War I and honoring troops who had returned to Washington County. (Courtesy UA Libraries/ WSC Collection, MC1427.)

Christopher C. Manuel and Lola Manuel and their family plant a victory garden in May 1943, one of many ways that Fayetteville residents contributed to the war effort during World War II. Families grew their own vegetables so that more farm-grown foods could go straight to the troops serving in Europe and the Pacific. The Manuels lived at 402 East Center St., and Christopher Manuel worked at Quality Shoe Shop on Center Street. (Photograph by *Northwest Arkansas Times*; courtesy Shiloh Museum/WCHS Collection, P-2437.)

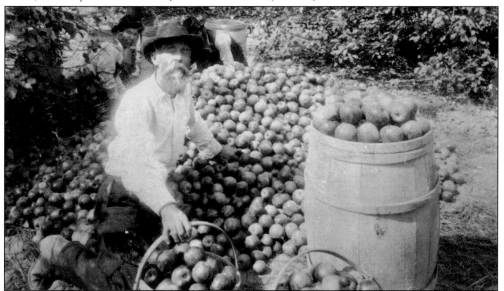

Luke Lea Kantz poses with bushels and barrels of his prize apple harvest, sometime between 1900 and 1910. He came to Washington County in 1867 and married Martha J. Skillern in 1870, settling near the intersection of Mission Boulevard and Crossover Road. He became a teacher and began growing apples in the early 1870s. He continued adding trees to establish an experimental orchard that produced apples from early spring to late fall, with different varieties ripening at different times. He attracted the attention of university horticulture professors, and some of his prize apples were shipped as far as London, England. (Photograph by John T. Stinson, courtesy Shiloh Museum/WCHS Collection, P-884.)

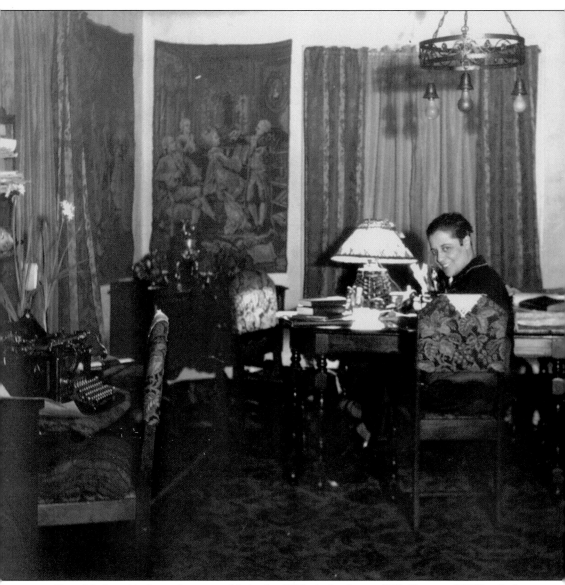

Rosa Marinoni is shown here, possibly in the 1920s, in her home, Villa Rosa, at 617 West Lafayette. Marinoni was Arkansas poet laureate from 1953 to 1970 and a tireless advocate for literature and learning, establishing Poetry Day in Arkansas and founding the University-City Poetry Club in Fayetteville. Villa Rosa was built in 1924 and was added to the National Register of Historic Places in 1990. The house remains in the Marinoni family. (Courtesy Shiloh Museum/WCHS Collection, P-1788.)

Several members of the Campbell family and their friends walk the perimeter of Trent's Pond about 1924. The pond was a popular spot for swimming, boating, and fishing during the summers. The pond included a slide, wooden diving boards, and a bandstand. For most of the 20th century, it was the only park Fayetteville had. It was named Wilson Park, in honor of Mattie Morrow Wilson. (Courtesy UA Libraries/WSC Collection, MC1427.)

William Simeon Campbell sits in his home on Lafayette Street. Campbell worked for the Fayetteville Chamber of Commerce during the 1930s, a period during which he collected many of the photographs reproduced in this collection. (Courtesy UA Libraries/WSC Collection, MC1427.)

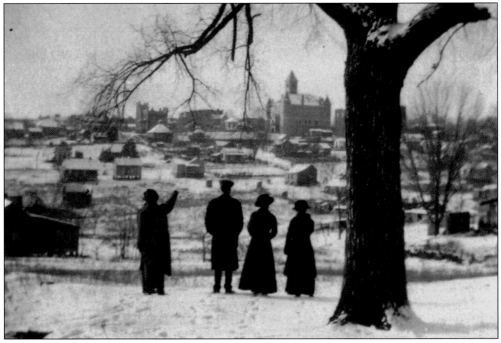

The Campbell family, bundled in fur and wool, stops along the southwestern flank of Mount Sequoyah after a snowfall around 1920. One points toward the 1905 Washington County Courthouse. (Courtesy UA Libraries/WSC Collection, MC1427.)

Walter J. Lemke sits in an easy chair enjoying his two vices, a cigarette and a newspaper, about 1935. Lemke founded the journalism department at the University of Arkansas and taught this subject for more than 30 years. He also helped establish the Washington County Historical Society and edited the society's historical journal, *Flashback*. He lived at 231 East Dickson St. (Courtesy UA Libraries/Walter Lemke Papers, MSL541.)

Annie Caughey lived for many years in the Buckner community on the east side of Fayetteville before moving, late in life, to East Davidson Street. On one of her buggy rides between Buckner and downtown Fayetteville, two men tried to hold her up during her evening return. She grabbed the whip, lashed them both across the face, and whipped the horses away to safety. (Courtesy UA Libraries/ Walter Lemke Papers, MSL541.)

Roberta Waugh Fulbright, publisher of the *Northwest Arkansas Times*, and son James William Fulbright look over newspapers at the *Times* office around 1943. The younger Fulbright went on to be senator for more than 30 years. (Courtesy UA Libraries/Walter Lemke Papers, MSL541.)

Sarah H. McIlroy, her daughter Mertye McIlroy, and her husband, James Hayden McIlroy, are pictured at their home around 1925. James McIlroy, in addition to carrying on the family's operation of McIlroy Bank, served on the school board and the Fayetteville Commercial League. (Photograph by J.H. Field; courtesy UA Libraries/McIlroy Family Papers, MC790.)

Minnie Bell Dies Field points a camera at her son, Burton, in this c. 1900 photograph. Unseen is the photographer, J.H. Field, an art photographer whose ethereal photographs won awards around the world. (Courtesy UA Libraries/J.H. Field Photographs MC539)

Charles Finger (center), his older son, Hubert, and Murray Sheehan are pictured around 1925 at the Finger family's farm, Gayeta Lodge. Finger was a novelist who moved to Fayetteville in 1920 and began publishing *All's Well*, a literary magazine with nationwide distribution. Sheehan was a journalism professor and author of *Half Gods*, a novel based on Fayetteville. (Courtesy UA Libraries/Charles Finger Papers MC639.)

The Lighton family sits on the front stoop of their home in the early 1900s on Happy Hollow Farm, east of Fayetteville near the present-day Happy Hollow Elementary. Novelist William Rheem Lighton and his family moved to Fayetteville in 1908. The house is still standing. (Photograph by J.H. Fields; courtesy UA Libraries/Lighton Family Papers MC779.)

Charles Ludwig Von Berg was a western scout and posed for this photograph in his frontier clothing, holding his rifle, Old Betsy. Von Berg moved to Fayetteville in 1904, built a house on East Mountain (now Mount Sequoyah), and started the town's first Boy Scout chapter. Near sunset each day, he played *Taps* on a bugle. (Courtesy UA Libraries/Von Berg Photographs MC863.)

Members of the Neighborhood Pigeon Club show off their prized pigeons in July 1941. Included in this image are, from left to right, (first row) Herb Lewis Jr., Jimmy Heerwagen, Tommy Lewis, and Billy Davis; (second row) Mildred Davis, David Heerwagen, Charles Crocket III, president Jimmie Murphy, Guy Duggan, Louis Davis, and Janis Adams. (Courtesy Shiloh Museum/WCHS Collection, P-2520)

The Washington County Historical Society, organized in 1950, has been holding its annual Ice Cream Social since the early 1970s on the grounds of Headquarters House. The social, photographed August 23, 1974, is the organization's largest fundraising event of the year and typically includes period reenactors, barbershop quartets, and cake and ice cream. The organization continues to support preservation, promotion, and education about the historical resources of the county and is the primary source of historical research about Washington County. (Photograph by Ken Good of the *Northwest Arkansas Times*; courtesy Shiloh Museum/WCHS Collection, P-630.)

INDEX

DISCOVER THOUSANDS OF LOCAL HISTORY BOOKS FEATURING MILLIONS OF VINTAGE IMAGES

Arcadia Publishing, the leading local history publisher in the United States, is committed to making history accessible and meaningful through publishing books that celebrate and preserve the heritage of America's people and places.

Find more books like this at
www.arcadiapublishing.com

Search for your hometown history, your old stomping grounds, and even your favorite sports team.

Consistent with our mission to preserve history on a local level, this book was printed in South Carolina on American-made paper and manufactured entirely in the United States. Products carrying the accredited Forest Stewardship Council (FSC) label are printed on 100 percent FSC-certified paper.

MADE IN THE

USA